PEDAL

PEDAL

PHOTOGRAPHS FROM THE 2005
CYCLE MESSENGER WORLD CHAMPIONSHIPS
NEW YORK CITY, ORGANIZED BY THE NEW YORK
BIKE MESSENGER FOUNDATION

BY PETER SUTHERLAND
TEXTS BY ZEPHYR, KEN MILLER & SWOON

 powerHouse Books New York, NY

Dedicated to Jan Sutherland

TEXT BY ZEPHYR

Local bike messengers—New York's unsung heroes—are singing out, loud and clear, and I love the sound it makes.

Heroes to some, pariahs to others, they put themselves at enormous risk every day as they make their rounds on the streets of the rotten apple. The bike messengers of NYC remain intertwined in a schizophrenic relationship with the citizenry. Nine to fivers love the messengers when they need them. And when do they need them? When they want a package delivered fast, of course. Which in turn requires fast riding, and that's when the same folks start to hate 'em—because a guy with a mohawk on a Cannondale with no visible brakes scared the shit out of them in an intersection.

Appropriate recognition for the bike messengers' role in greasing the monster gear of the daily urban grind does not appear to be forthcoming. Wisely, the messengers have stopped waiting for props to come from outside their world. Today's pony express on Campy cranks has banded together, pooled their resources, and gotten organized.

When I was on the job, Steve the Greek was the handle of the guy who saw the need for messenger unity and mobilization. When the mayor implemented a bike ban in midtown Manhattan in 1987, it was Steve who organized the protests that helped dismantle the draconian move.

I remember the day when all the bike messengers converged on the west side of Houston Street to hear Steve deliver his message to the troops. Word had been disseminated on the streets throughout the day—we were anxious about the impending ban that would destroy our livelihood, but we were giddy with a new awareness of our collective strength.

When the bike ban rallies occurred, it was the first time we had ever gathered en masse, and the experience was both empowering and euphoric. We rode in a huge pack, slowing traffic to a crawl, chanting down the proposed ban. The bike messenger protest rallies on the streets of New York City during September 1987 may have laid some groundwork for the Critical Mass movement that was to

follow, but more importantly, they forged us into a group. Real negotiations regarding unionization, health benefits, and safety issues were outgrowths of the messenger rallies of '87.

To my delight, bike messengers today have firmly grabbed the ball and run with it. In my day there were no bike messenger coalitions, no bike messenger unions, no bike messenger websites, no bike messenger races, no bike messenger periodicals, and certainly no bike messenger world championships. And while there was an occasional media nod to our outlaw pose, the mainstream primarily just relied on us for their deliveries. Today, all that has changed, and, to their credit, it is entirely the messengers themselves who have created the better scenario.

While thin, tattooed guys and dreadlocked gals on Italian track bikes seem to represent the messenger elite, I'm going to throw some love to those I'll affectionately refer to as "all the others." All the others work just as hard, eschew any notion that there is a messenger fashion sense, and are on the phone with the dispatcher at 7:00 AM in a Monday morning rainstorm. Their saddle broke a year ago; they use a bundle of rags instead. Their footwear is by Glad, not Sidi, and they seem to think gloves are irrelevant, even at 15 degrees Fahrenheit.

Cash, a 60-run-a-day messenger who cleared $1,000 a week every week for decades, looked like Woody Allen, had no affinity for aerodynamic equipment, and favored a banged-up Trek road bike over a fix. He wore a lumpy wool cap to keep his ears warm, and always had snot in his moustache.

And on the subject of the others, let's give props to the dispatchers. The bike messenger world is really a two-person game. It is the marriage between the messenger and the dispatcher that makes it all happen, and the dispatchers get sorely overlooked. So remember them, and buy 'em a beer on Friday.

With Alley Cat races, International Championships, and extensive social networks in full effect, things are looking up in messenger land. But let's not get too Pollyanna. The streets are still hell, claiming victims on the regular. Blood is spilled and lives are being lost in senseless, horrible carnage. This has to end. But stay tuned.

Fossil fuel is running out, and cars will rot in piles, relics of our past excesses.

The messenger community is evolving into a vibrant, vital organism. Things are starting to smooth out a bit, like you're hitting the road, it's Friday, you're going home, you're still alive, you have a pocketful of money. You grab a 53x15 gear and there's a nice tailwind....

TEXT BY KEN MILLER

Riding a bike is a good thing. It's good exercise. It gets you outside. It costs almost nothing. It's good for the environment. So why is it that, almost every time I ride my bike around New York City, I end up wanting to murder someone? Perhaps it's because, rather than spending my time enjoying the breeze on my face, the healthy ache of my legs as I pedal, the smug satisfaction of knowing that I'm using the simplest, cheapest, all-around best form of transportation ever invented, I spend most of my time dodging cars, trucks, potholes, pedestrians, and even other bicyclists.

Riding a bike fills me with hatred for the rest of humanity. They're blind, thoughtless idiots. They don't seem to know how a turn signal works. They don't bother checking for traffic before stepping out into the street. They need to get the exhaust system on their truck checked. They need to learn to not swing their car door wide open without so much as a thought about the person passing by that they are about to cripple. They need to get the hell out of my way.

I've never actually attacked anyone over these transgressions, but I've come close. I'm certain that the heavy piece of chain I use to lock my bike to lampposts could also be used as an effective weapon. If only that bastard who cut me off and nearly crushed me to death without so much as a second thought, and who then tried to deliberately back over me when I slapped his vehicle's molded fiberglass exterior with my bare hand, if only he would work up the courage to climb out of the cab of his truck and fight me like a man. Then we'd see how tough he is without 2,000 pounds of metal to protect him. After all, I ride a bike. I'm in better shape than he is.

To me, riding a bike is about aggression. And I just bike to work, I don't bike for work. I spend an hour a day, tops, riding my bike. I can't imagine the bottomless well of rage I would tap if I rode through the streets of the city for a full eight-hour workday, five days a week. Getting killed to deliver society's legal documents and oversized packages? Forget it.

I have only been in one bike accident, and it was nearly ten years ago. Remarkably, it was caused by a pedestrian, not a car. I was living in San Francisco and was on my way to work when someone stepped out from between two cars at a busy intersection. Next thing I know, I'm sitting on the pavement, face bleeding, my left arm hanging uselessly at my side. One helpful bystander thought to prop by bike up against the curb for me. Everyone else walked on by as I struggled to my feet, locked my bike up (using only one arm), limped to an ATM machine, retrieved cash, hailed a cab (because there was no way I was paying a thousand-plus dollars for an ambulance), and got myself to a local hospital.

Now I am a reasonably well-established member of mainstream society. I live in a gentrified neighborhood. I work full time. I have health care. And yet, the minute I set foot on my bike's pedals, I feel completely out of step with the rules of order that surround me. And, apparently, most of society doesn't feel much obligation towards me. I can only imagine what my mental state would be if I rode my bike for a living. Rules of the road? Fuck you. Right of way? Fuck you, too. Wear a helmet? Please. Since when do the laws of "safe conduct" work in my favor?

That's what it's like to be a bike messenger. To be in the midst of the flow of traffic, commerce, workaday humanity, yet completely removed from it. Not quite in opposition to the laws and norms regulating automotive and foot traffic, but knowing that those laws were not made with me in mind, that they don't address my concerns, that they more or less don't apply to me. For 100 dollars a day, 20 deliveries a day, they're just impediments thrown in my way. I can't ride on the sidewalk? Try riding through a midtown traffic jam with trucks pressing in from both sides, then decide if the street is the best place to be biking. Follow the street signs? As if I'm really going to go around the block and through three extra intersections and three extra sets of crosswalks and cross-streets when my

destination is half a block away, upstream. Obey stoplights? Apparently most lawmakers have not heard of the law of inertia, which maintains that a bike can be ridden most easily when you maintain momentum....

Which makes me realize that I'm getting it wrong in becoming so angry. Riding a bike is good exercise, in that it gets you closer to the environment in a way that is more than physical. It's a good exercise in stepping out of the bounds of society. It's a good way of understanding the dominance of physical law above all others. And it's this moment of removal and of superlative clarity in your relationship to the environment around you that makes riding a bike so appealing. When you've realized that the rules of normal daily life weren't made for you, but that you've found a way to earn a buck while sliding past their bounds, then you feel that you're free.

TEXT BY SWOON

On account of having grown up off a dirt road in the country with horses and chickens, we didn't ride bikes too often. One year, though, when I lived with my dad, my sister and I got bikes to ride to school. Mine was a boy's dirt bike. Black. I wore high-tops, and let my hair flip sideways across my face and my shirts hang off one shoulder. I picked fights with the sixth grade boys if they tried to steal my parking spot. I thought I was so tough. The next year I started painting, became introspective, and forgot about being a tomboy—forgot about how it felt to be in a crew riding home from school on the 3,000-degree Florida blacktop.

Two years into living in Brooklyn I missed my stop while reading on the subway, and I somehow hit upon the idea of getting a bike. None of my friends were riding except my buddy Paul, a dreaded messenger with one front tooth, who smelled of a windy freedom and all of those beautiful boys with their ragged pants and funny black socks. The devil may care, but not we. No not we. My god they drove me crazy.

I went to Recycle-a-Bicycle and got myself the miniature-est purple mountain bike (hot pink brake lines, fat tread tires). I was scared to get anything bigger, scared to ride it down the street—it took me

six months to cross the bridge into Manhattan. But one day I turned around and I was obsessed, and then so was everyone else I knew, and then, holy hell, we were in packs tearing up the 3,000-degree blacktop again.

Biking became essential to my view of the city, and my work—postering—choosing spots, exploring new terrain. The bike rodeo was coming to town, the Black Label Bike Club was making the best mayhem in Brooklyn, and Critical Mass was 1,500 strong and screaming. Summers were blazing bliss and winters reminded you what tough as nails meant. And what else was going on in the world?

Well somewhere in there the planes had hit the towers, and the oil barons had started taking a more aggressive approach to the pipeline. The bombs were falling on Baghdad and the first orders given were to not burn the oil fields. In all of the ways we dreamed to say "Fuck you!" to those that would implicate us in this travesty, our bikes seemed central. For all of our trying, we could not stop them from murder, pillage, and wars of aggression; but they sure as hell weren't going to sell back to us what they had stolen. Thicker than blood.

The picture was this—they: heavy beasts, slouching, slow and stiff with the weight of consolidated power, murderously desperate to preserve a system that is strangling itself; and we: swarming like locusts, laughing like hyenas, stinging like bees. When the RNC Critical Mass Ride swelled to 5,000 people and the police decided to target it (and they have continued targeting it since), it came as no real surprise. Bikes were the one element connecting half of the subcultures in New York. As a symbol of freedom they are way too tangible, too kinetic, and too potent and real. The police chased us down alleyways and the pedestrians cheered. "Beat 'em! Go this way! Get away!" Swarm, disperse, regroup. They cut off one head and we popped up in seven more places, free and spinning like tops. That pretty much brings us to the present. It's December as I write, winter is here again, but if you don't already have a bike, don't let that scare you. Get a beater to start with, scream at some taxis (watch for the doors), feel the cold burn in your lungs at the top of the Manhattan bridge at night. I swear, I swear it will change your life.

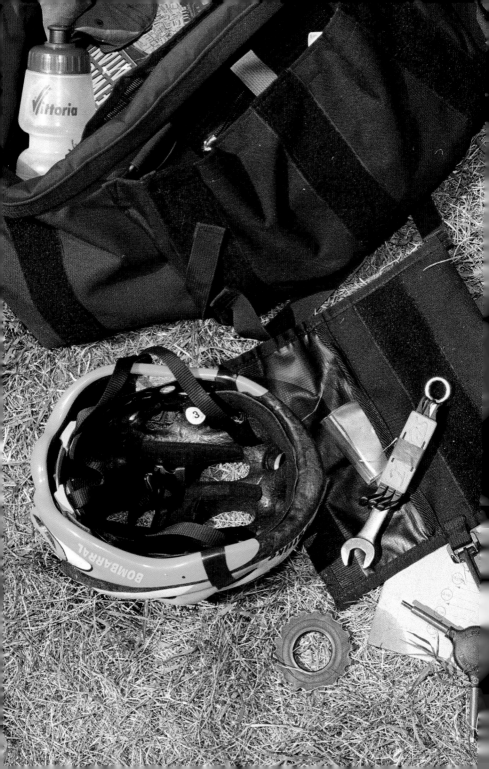

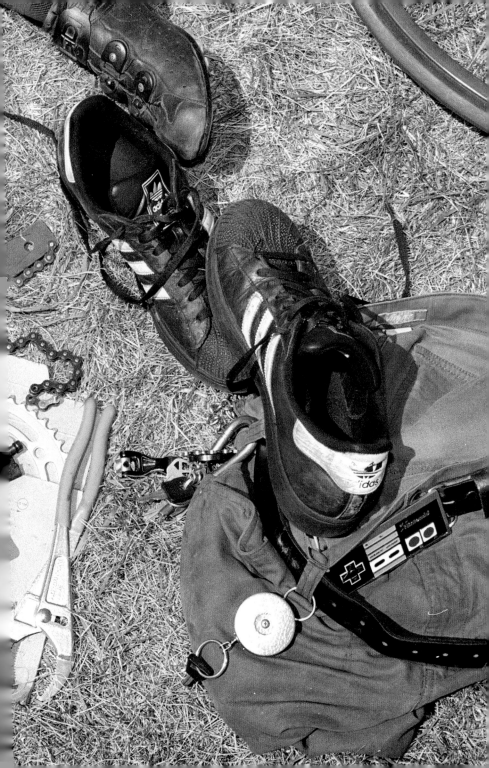

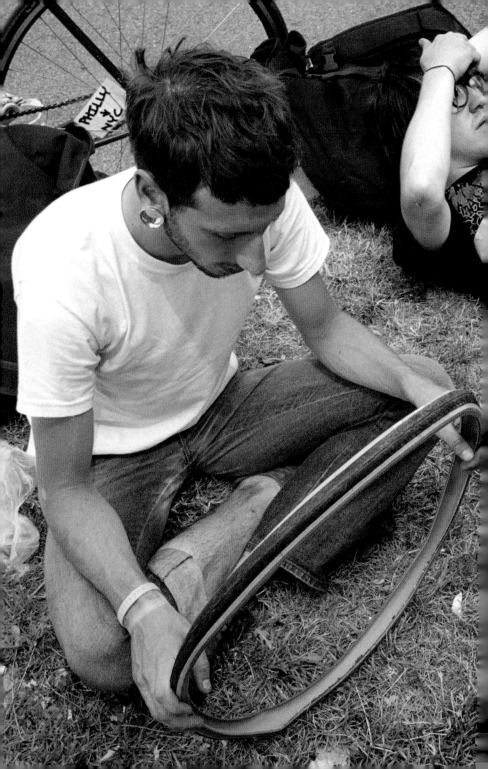

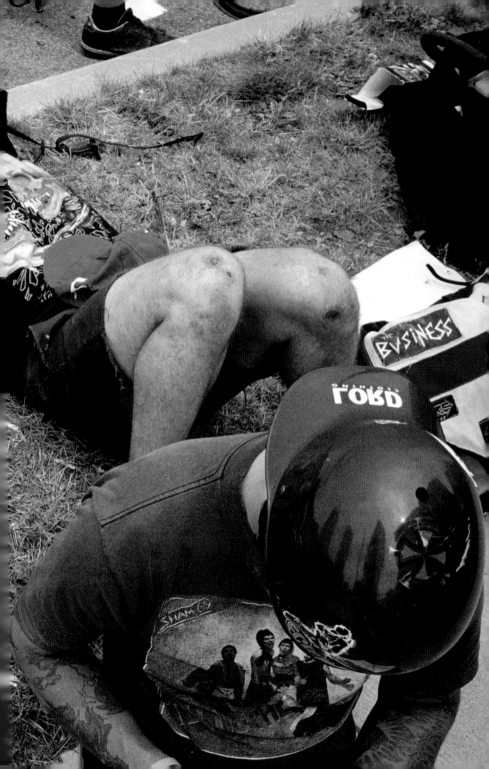

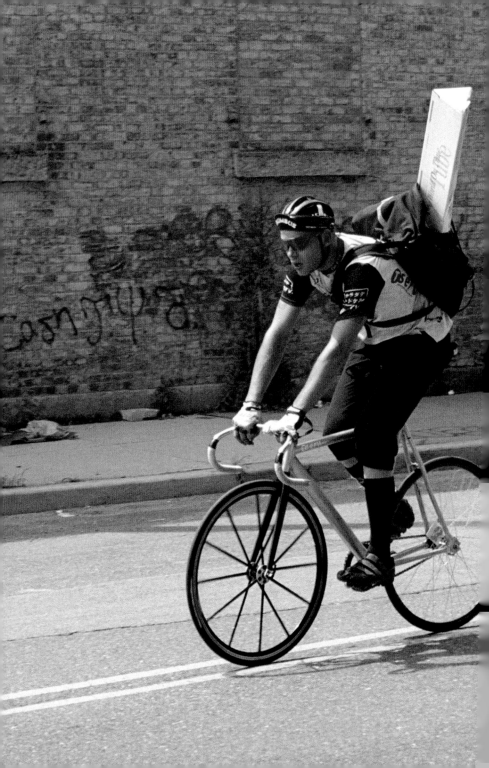

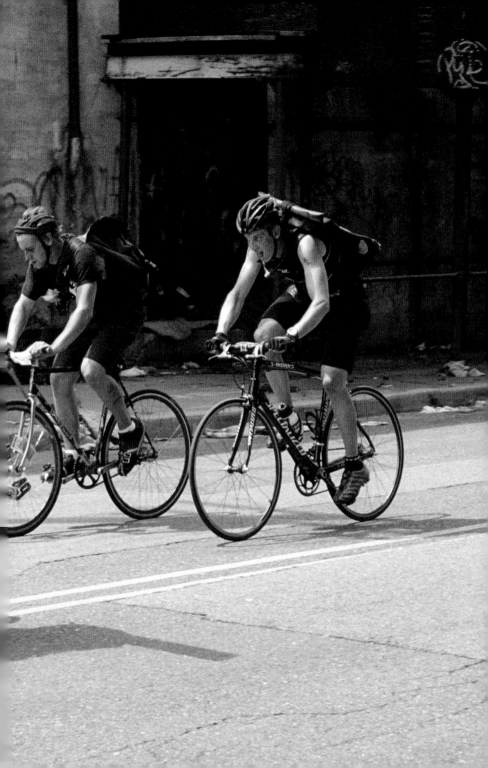

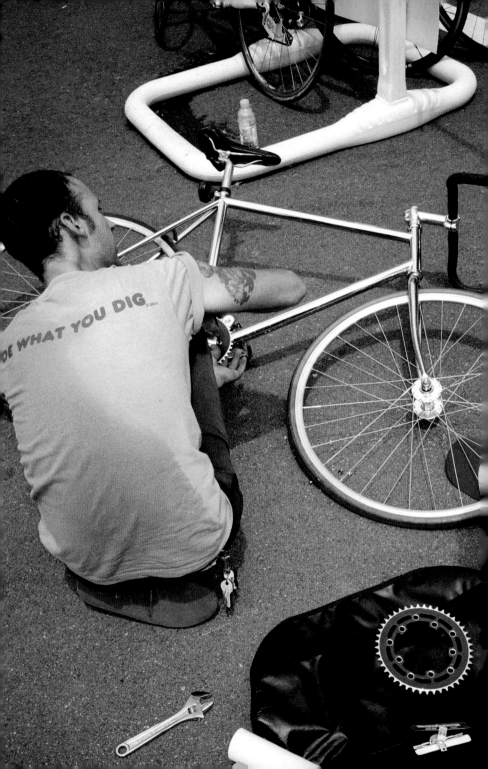

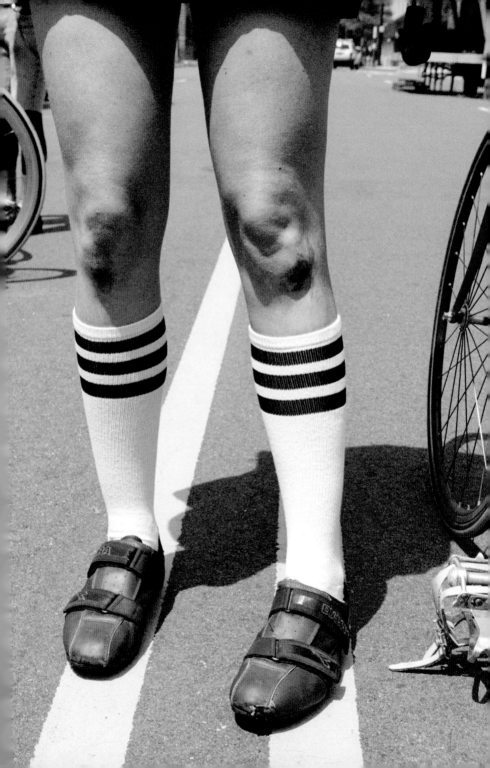

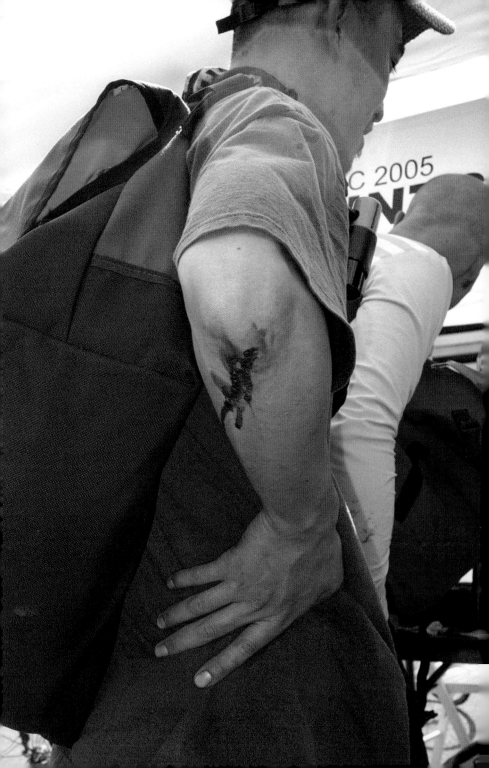

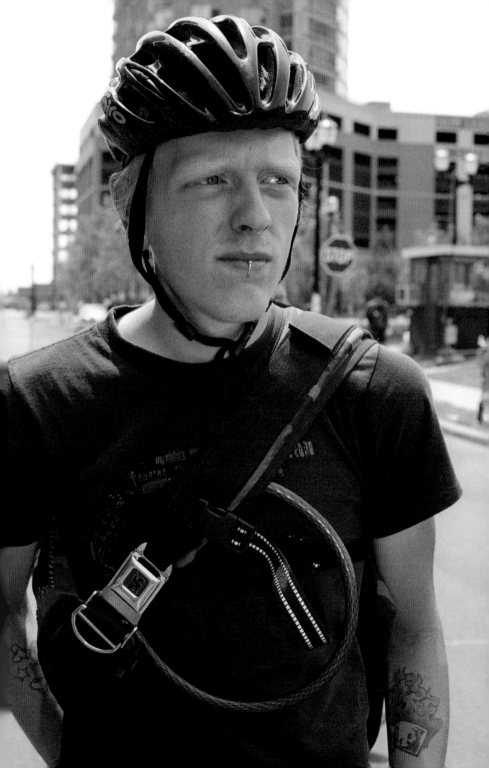

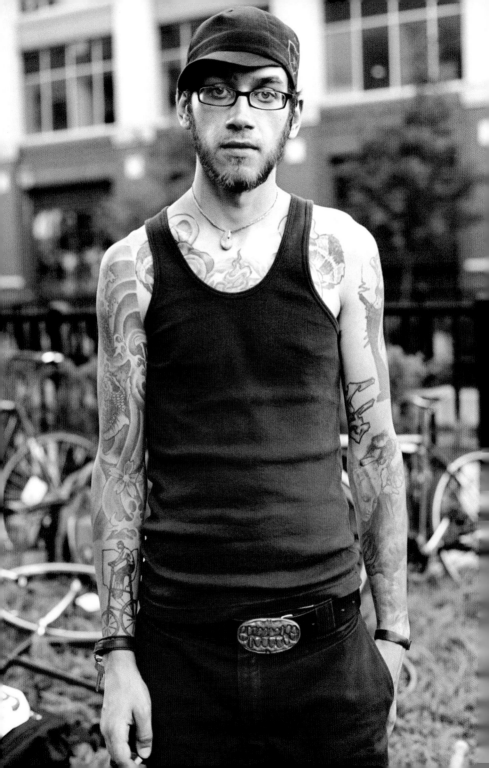

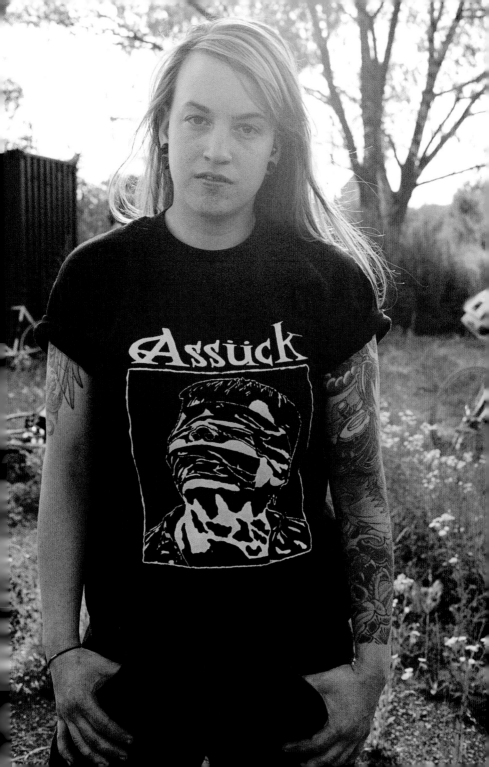

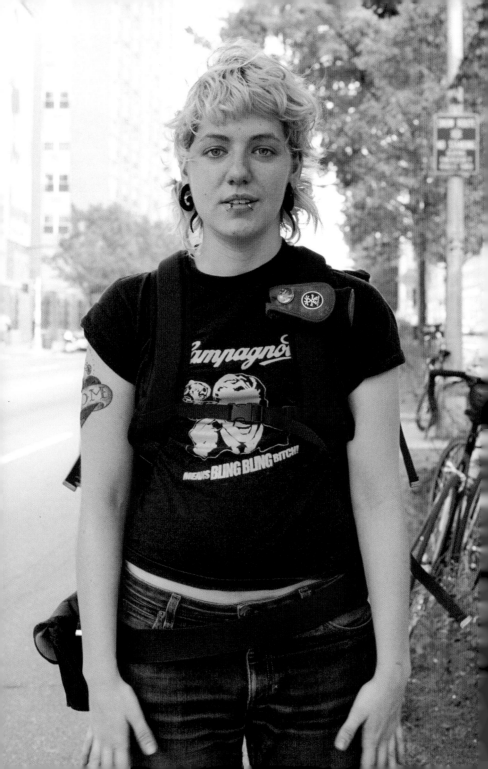

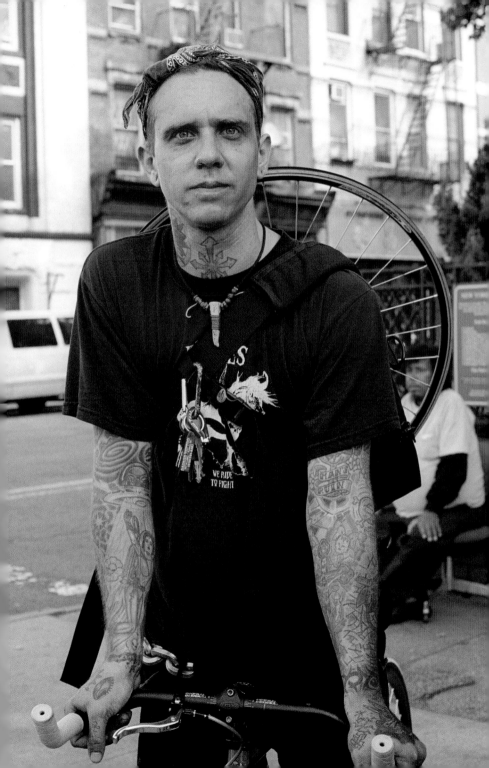

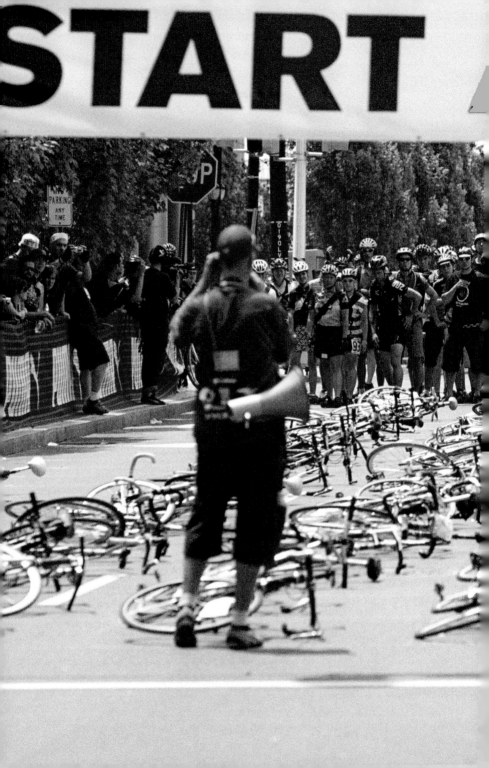

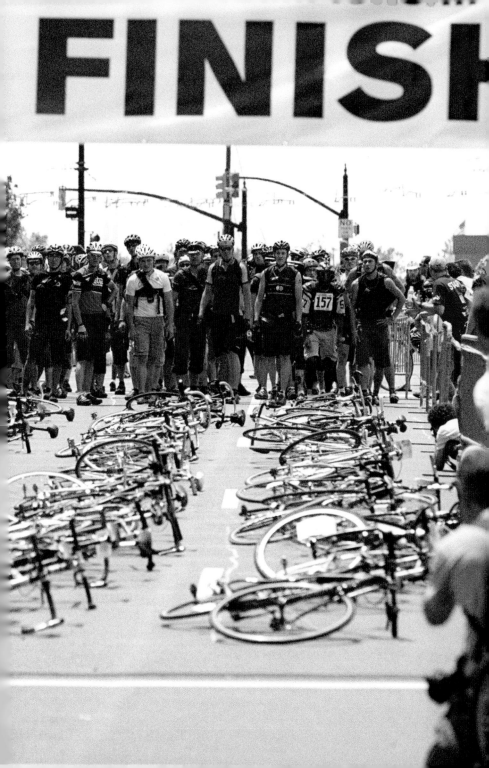

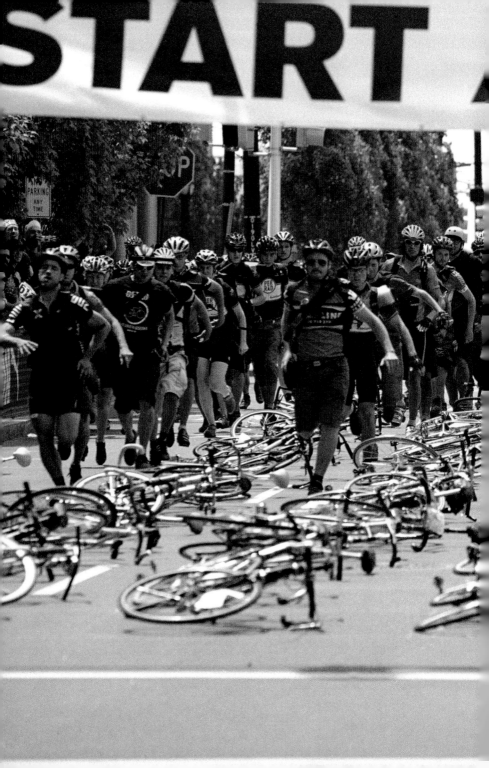

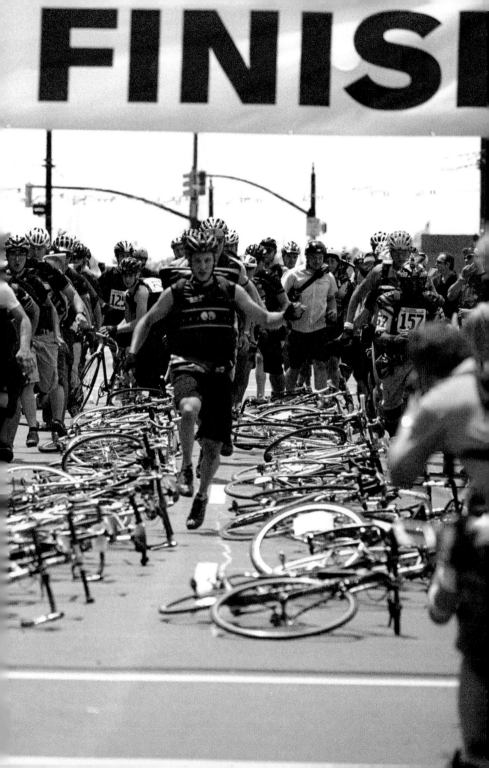

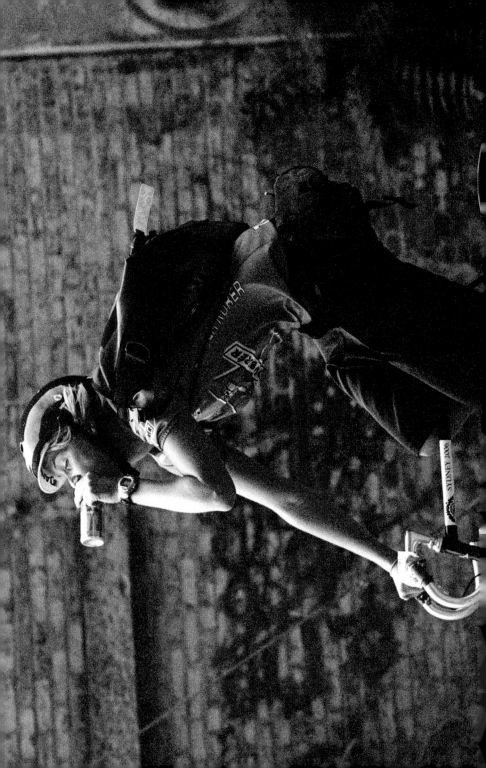

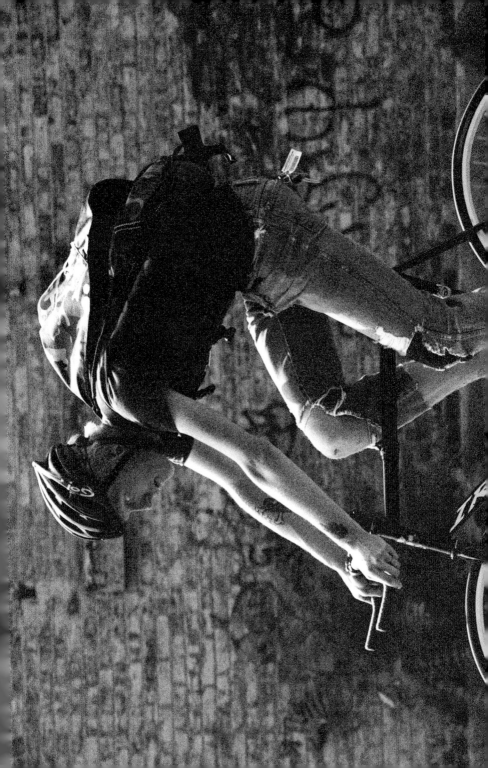

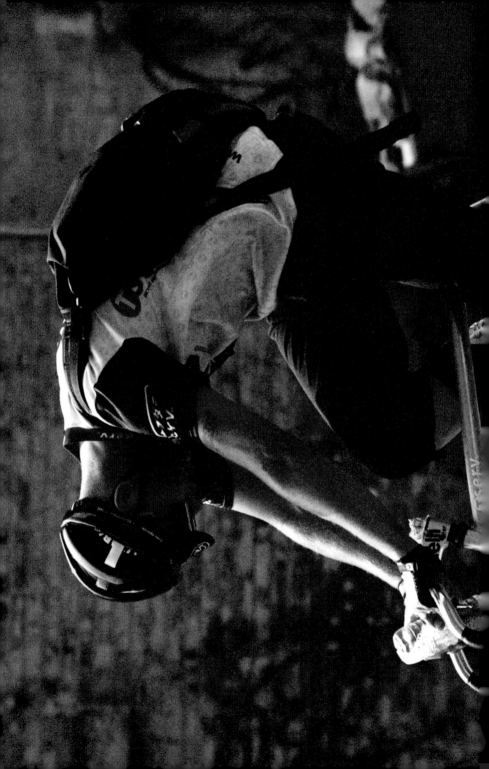

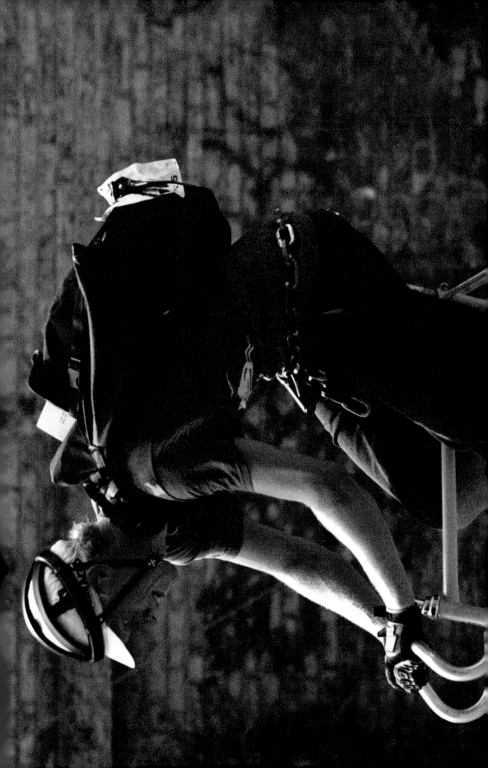

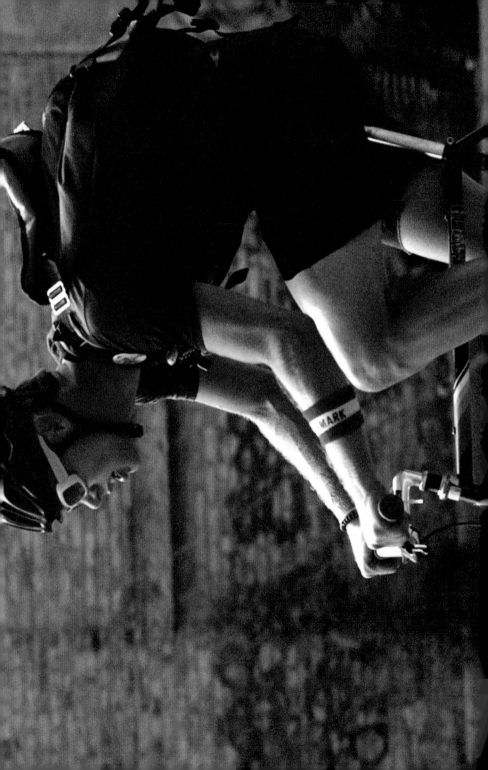

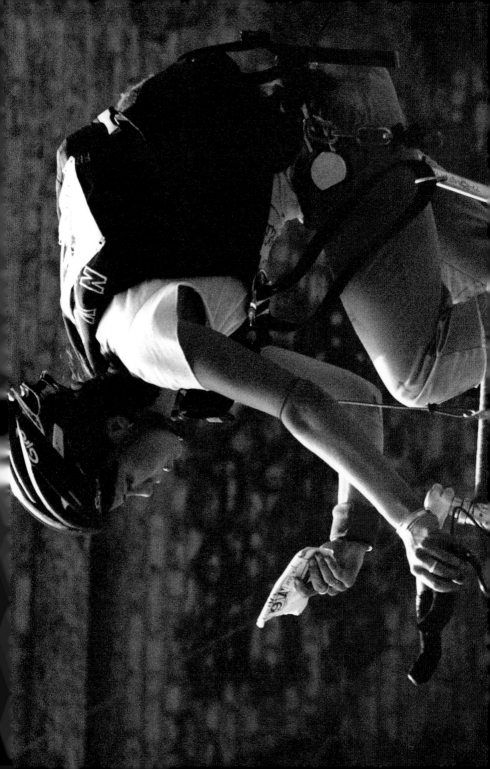

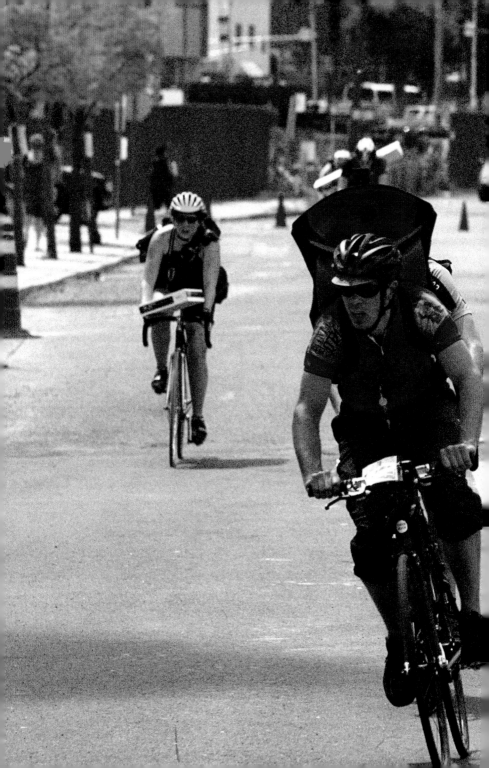

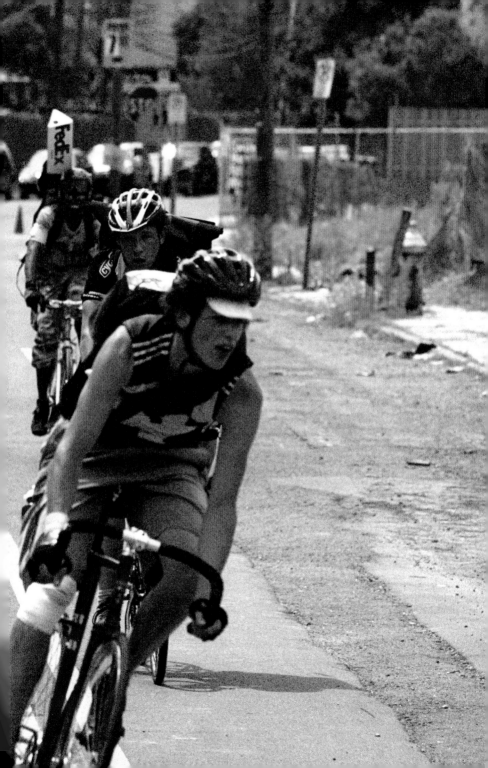

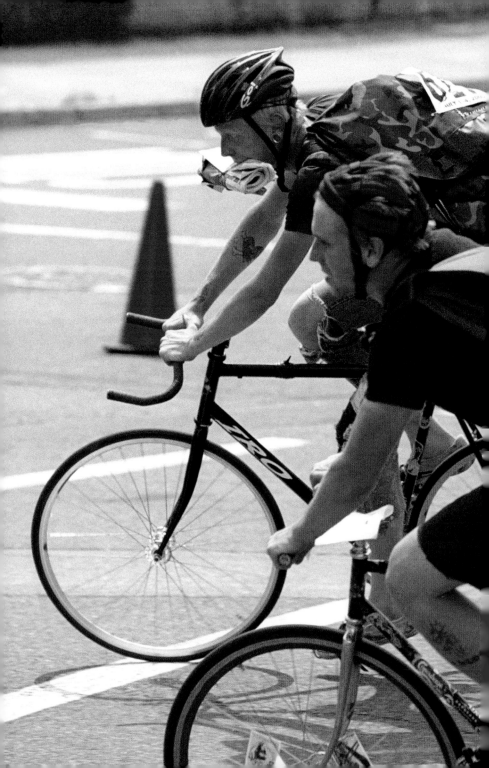

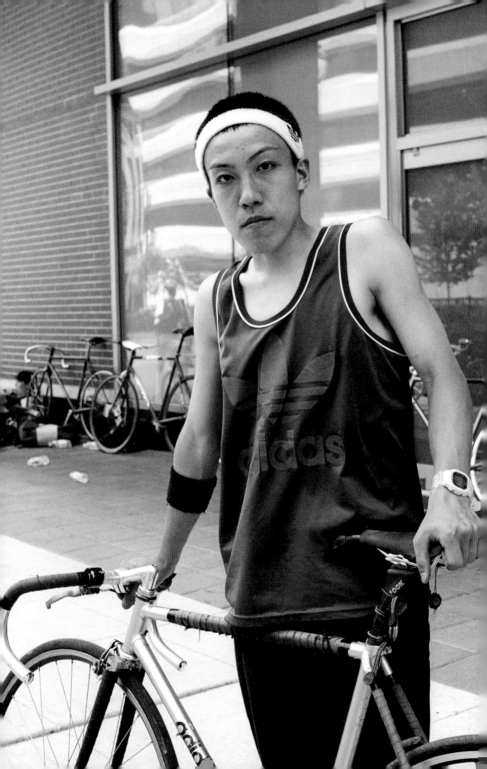

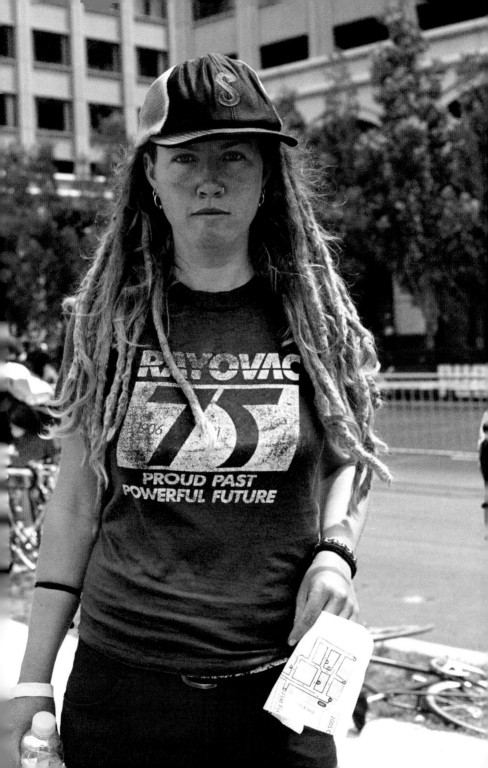

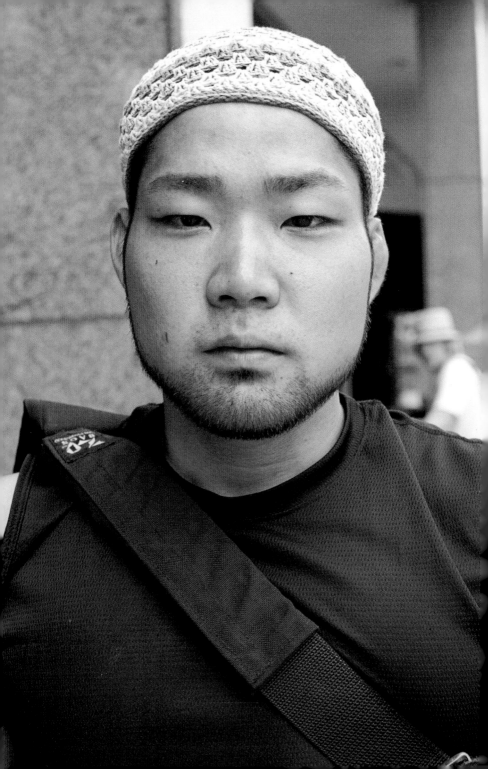

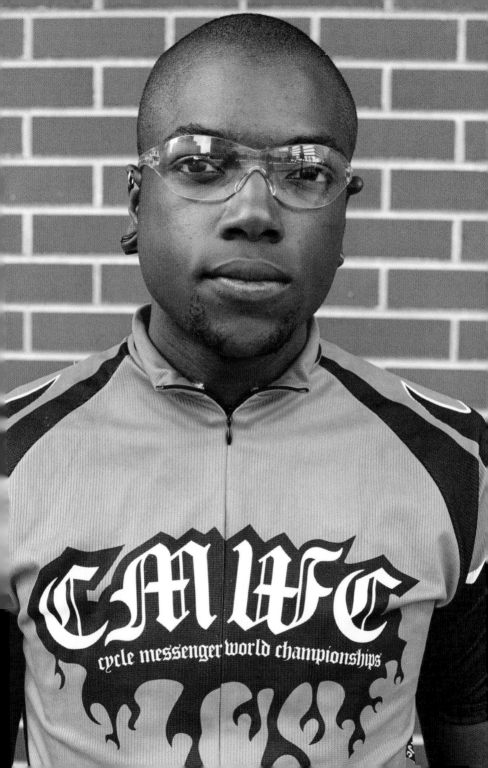

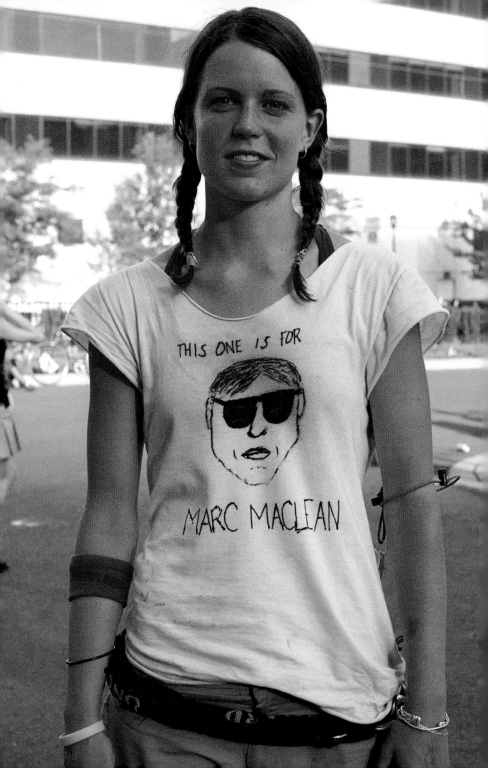

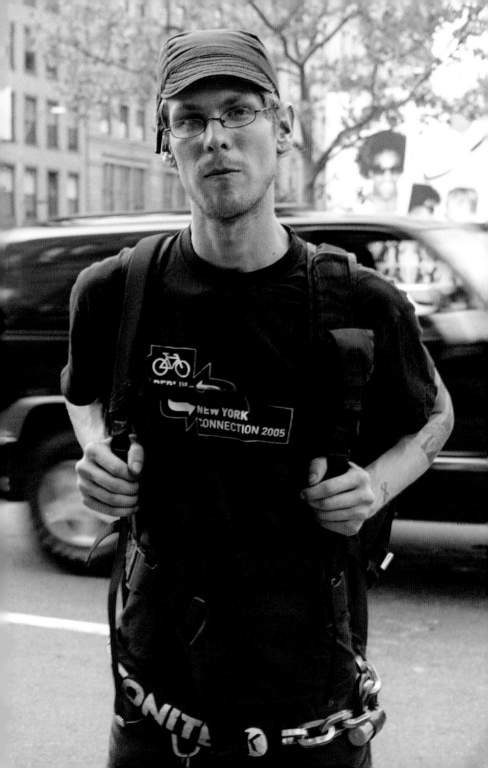

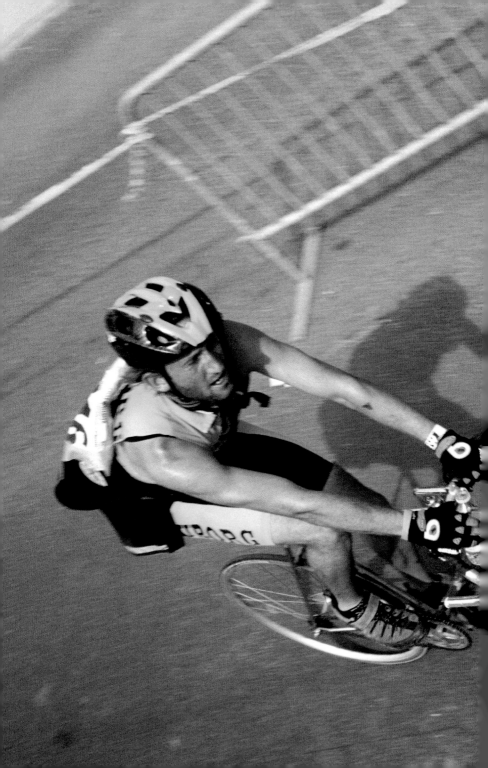

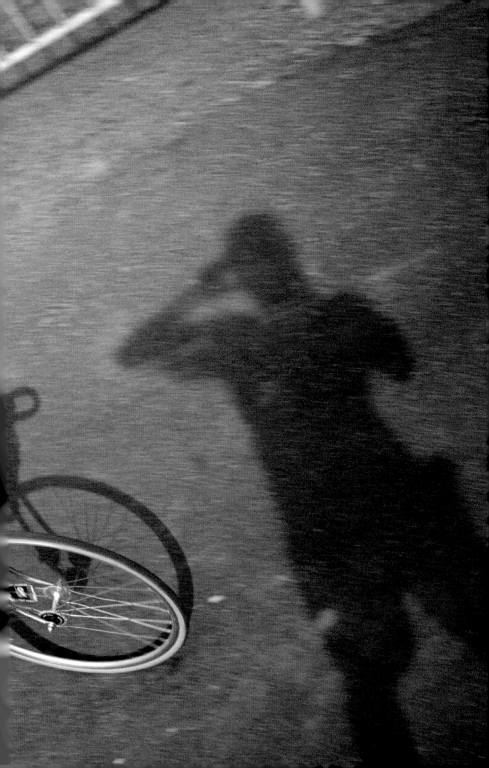

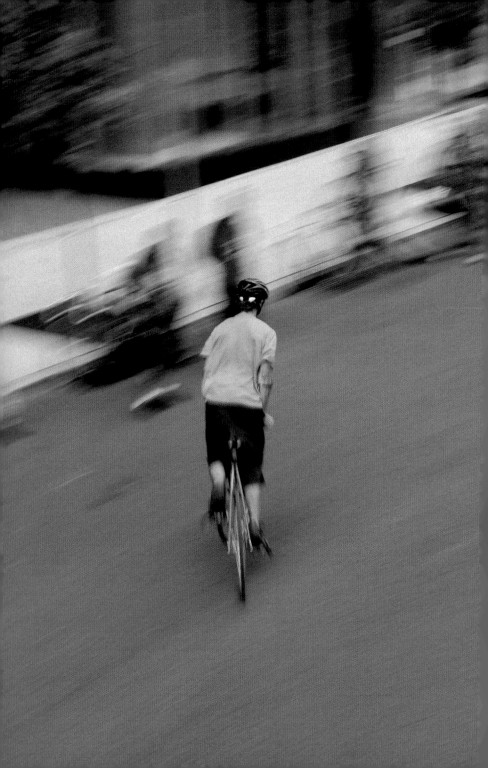

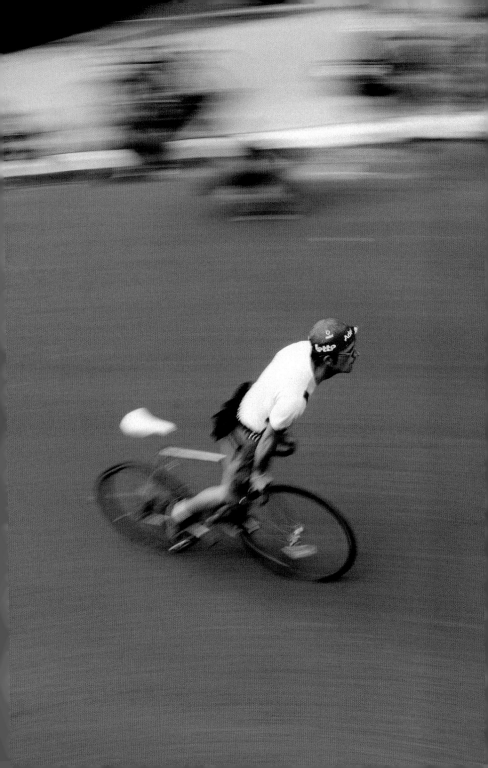

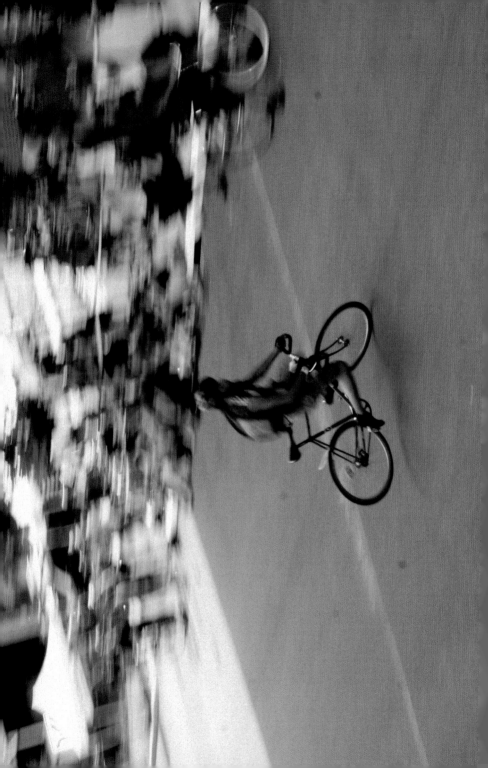

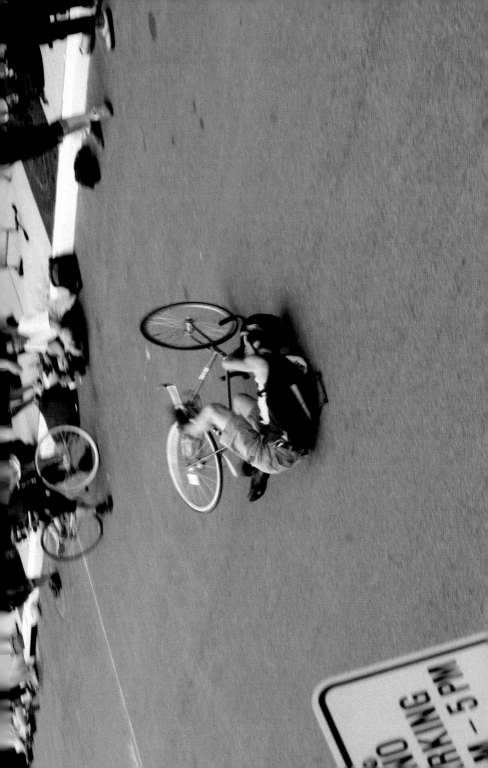

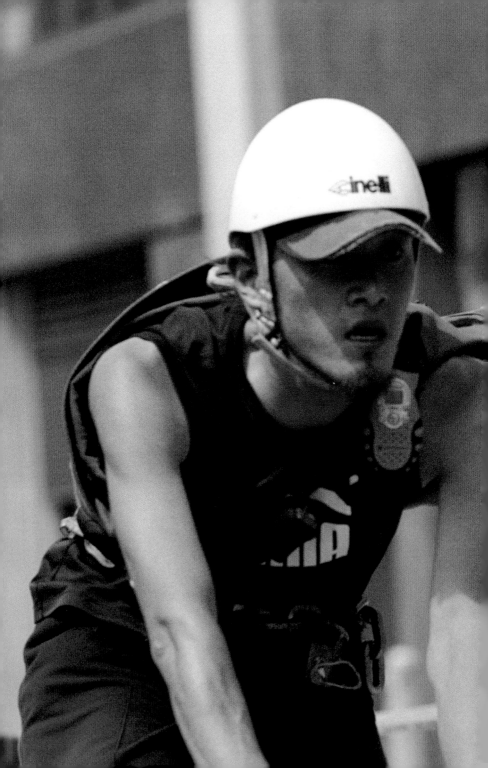

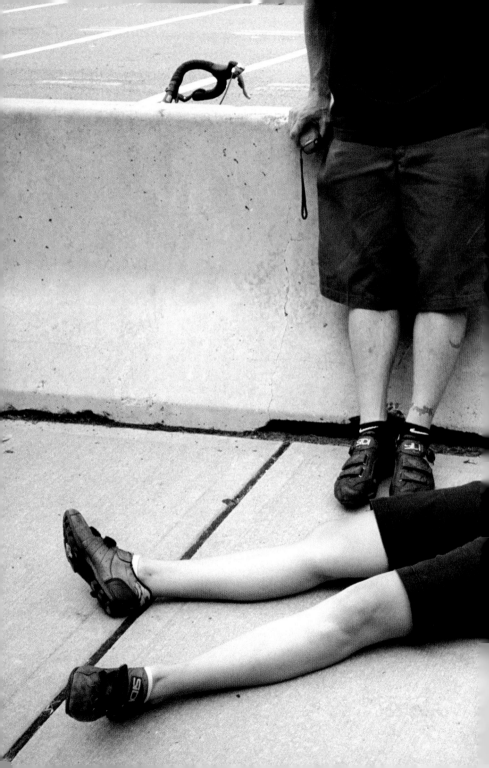

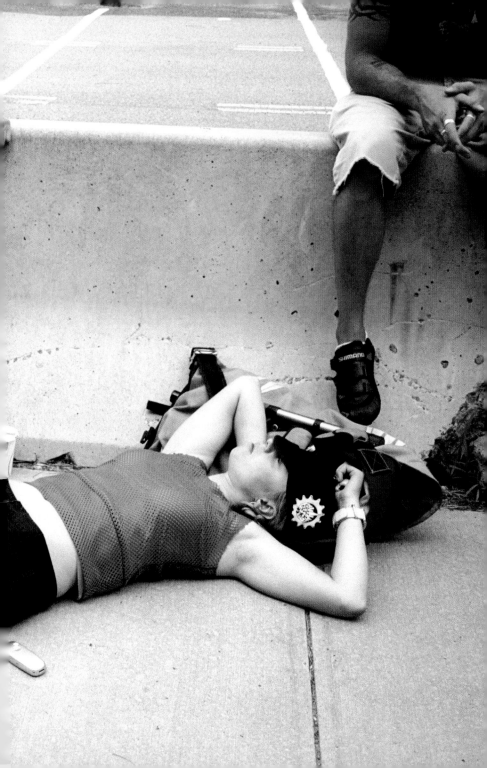

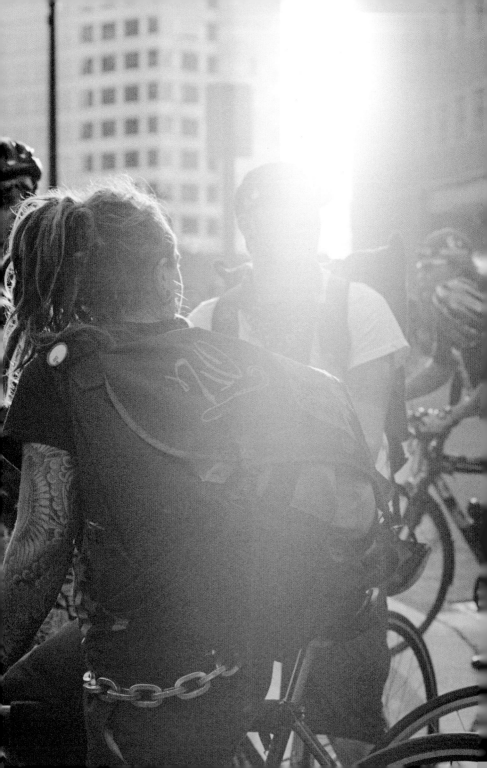

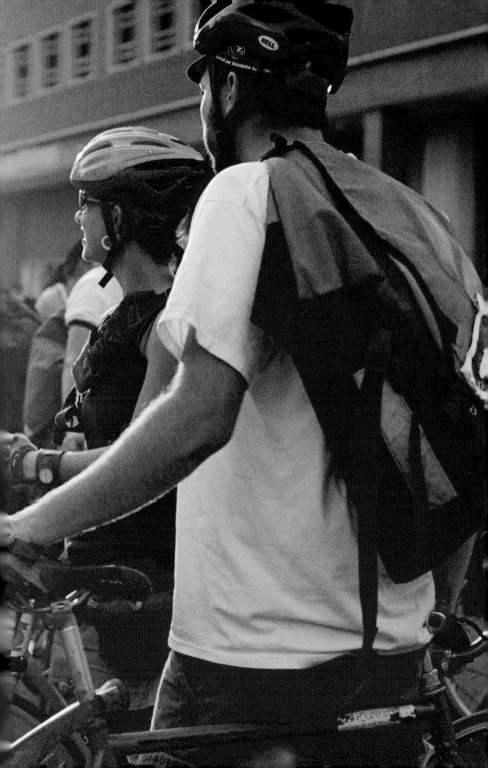

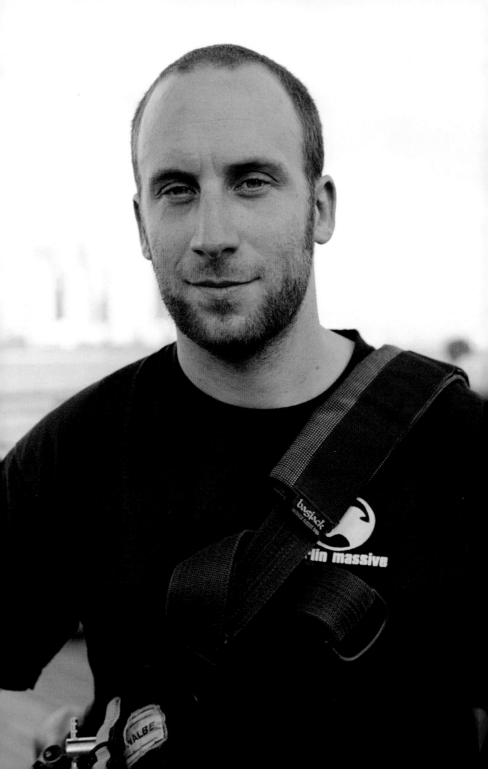

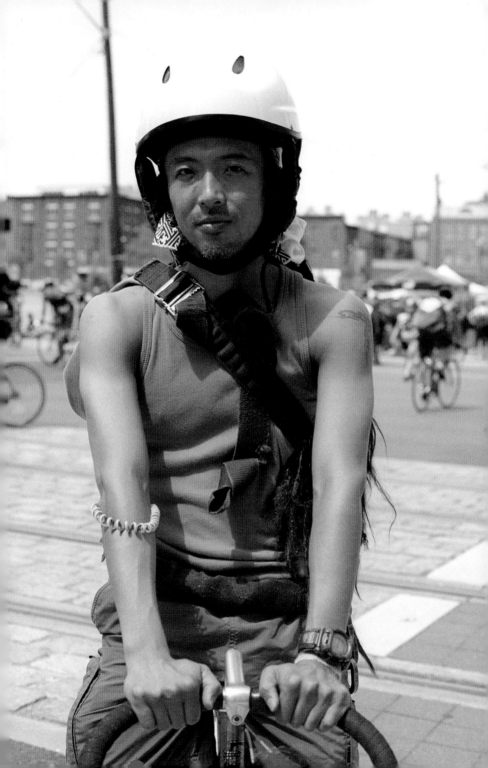

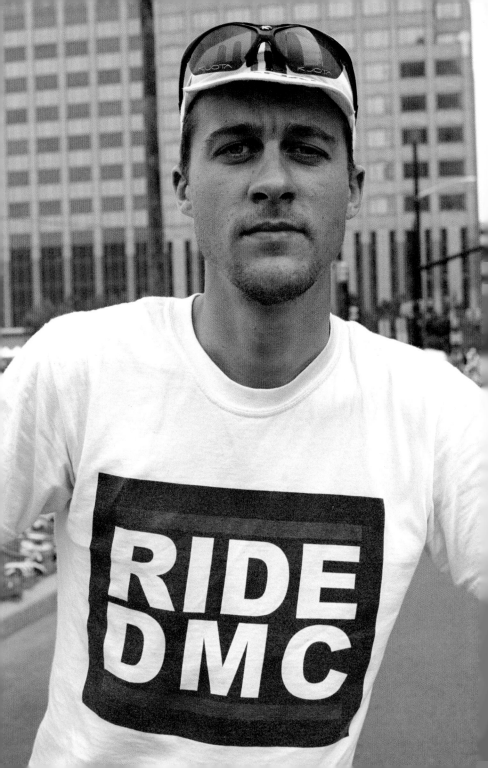

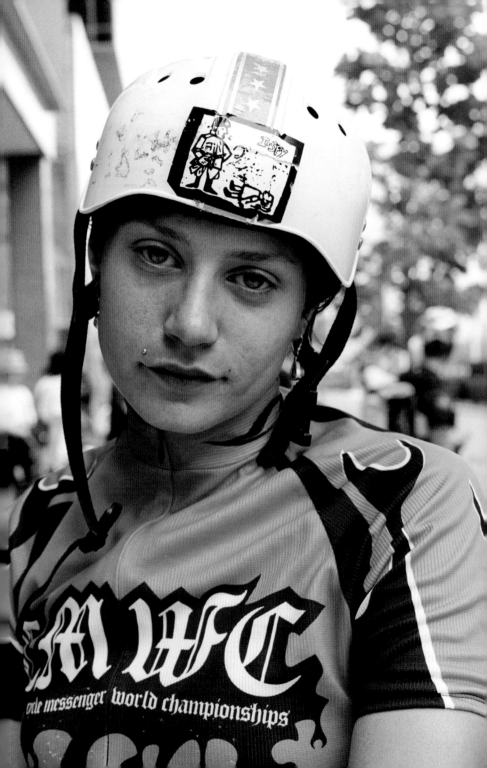

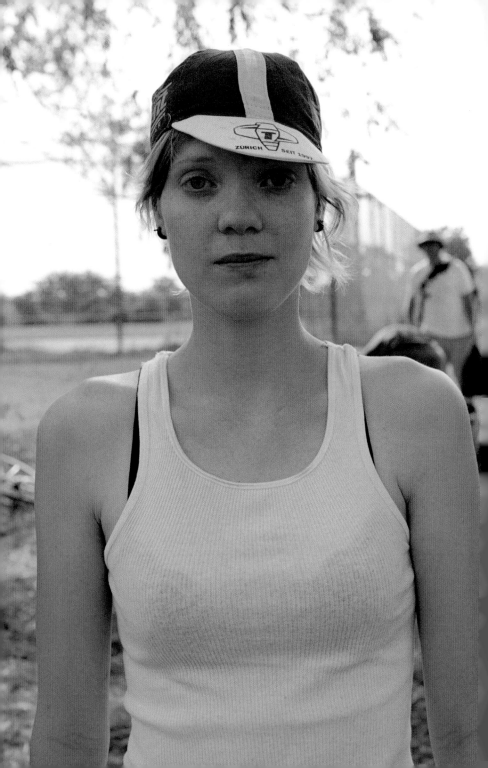

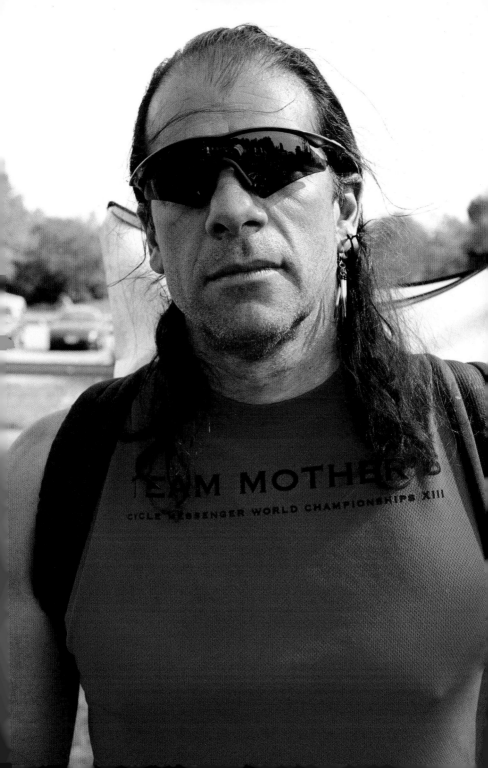

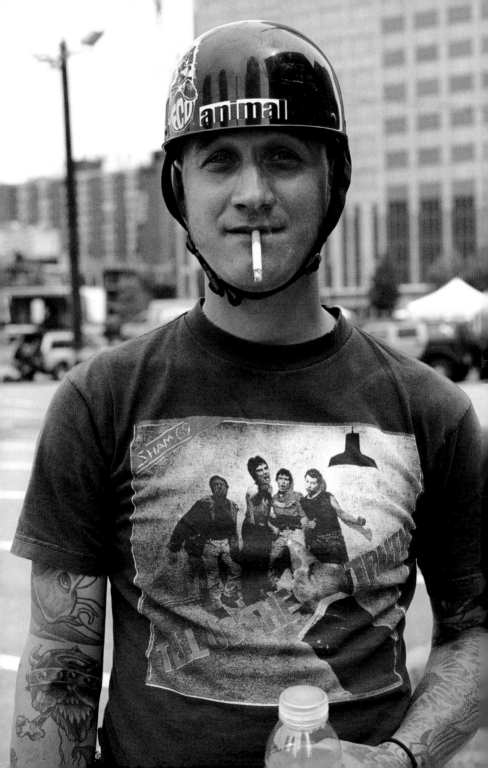

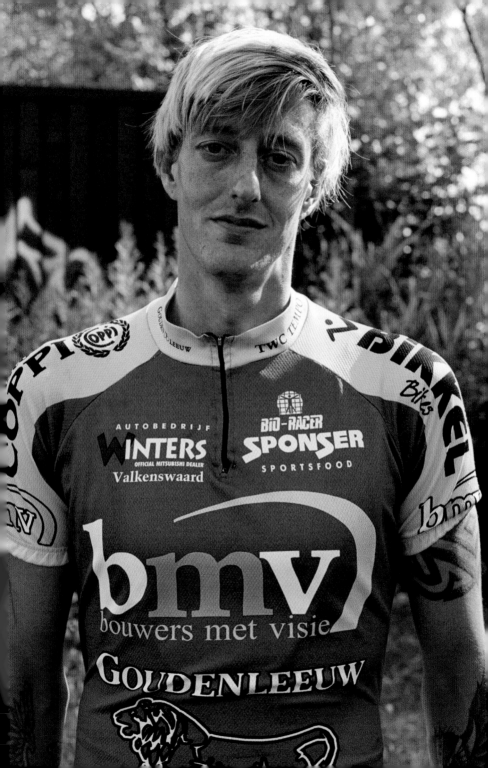

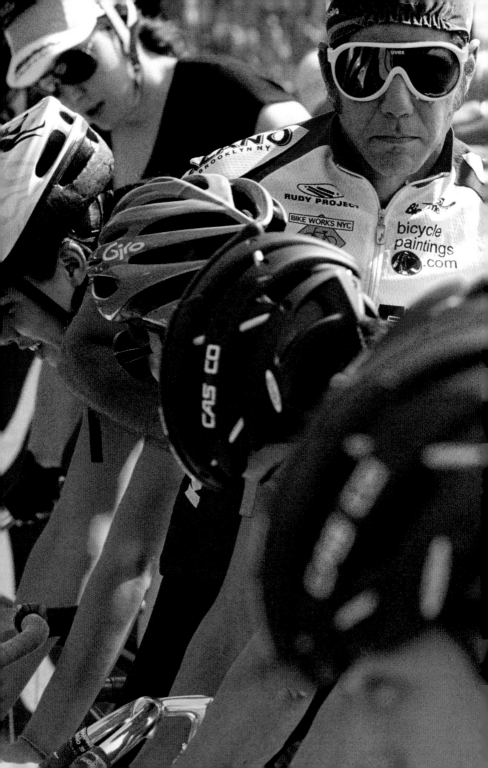

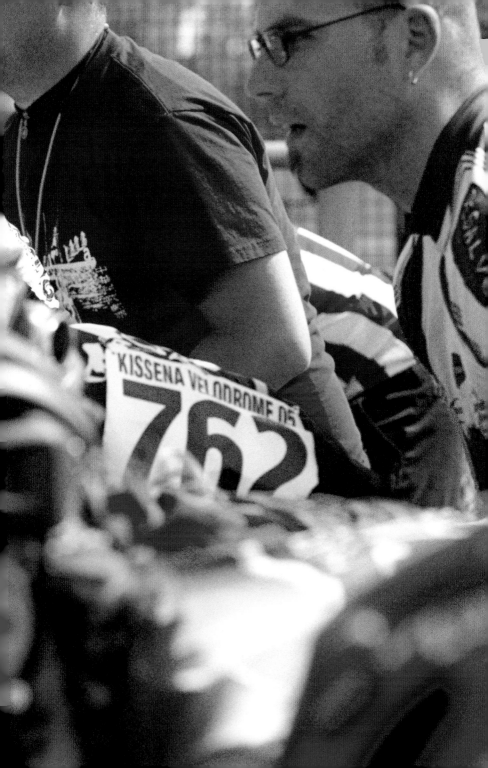

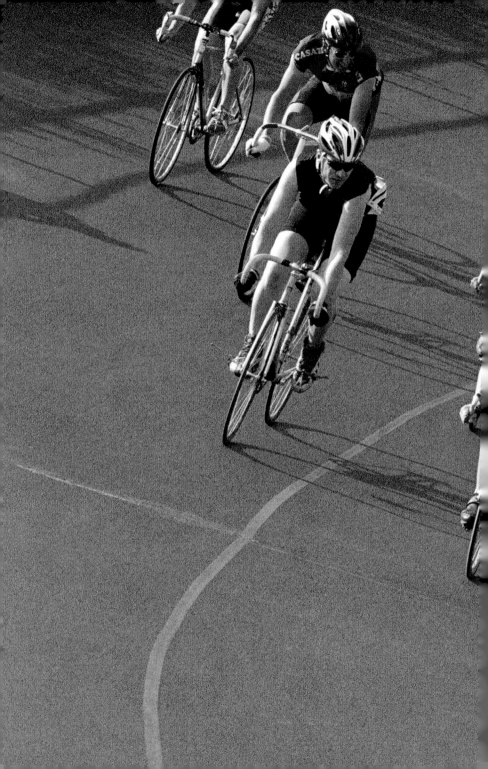

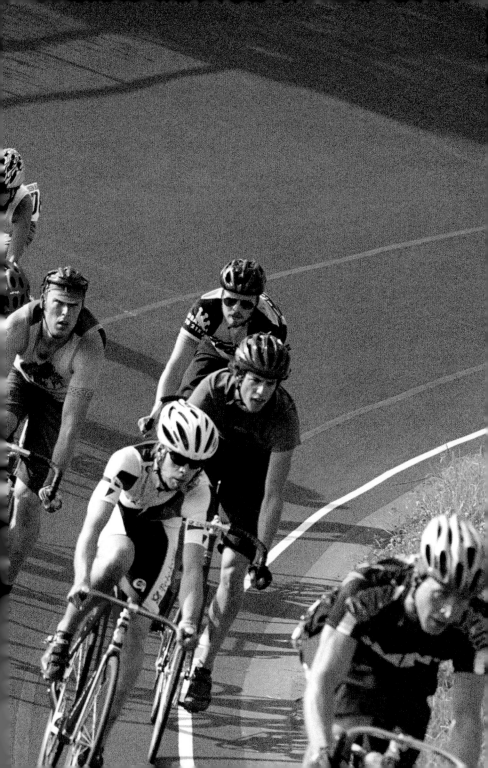

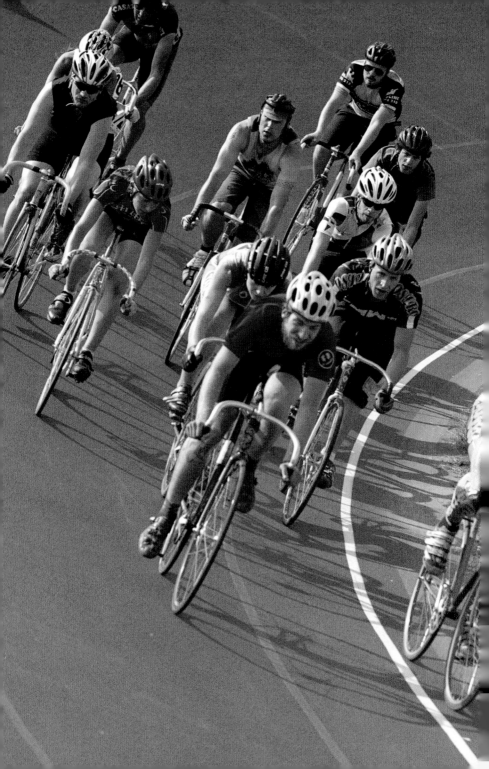

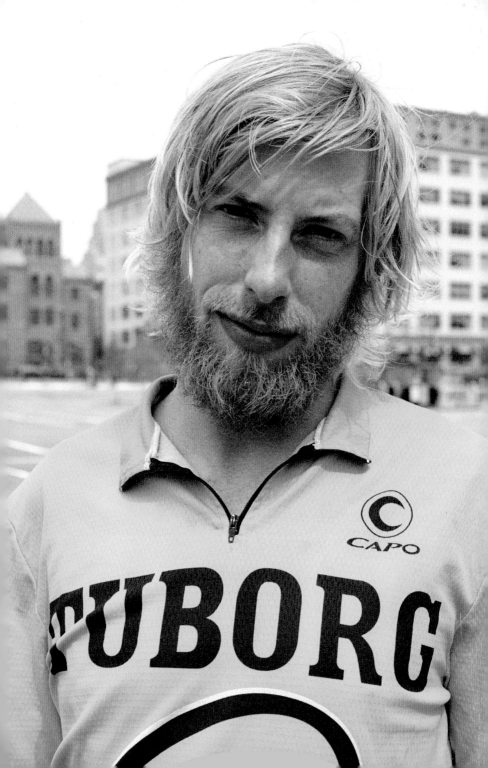

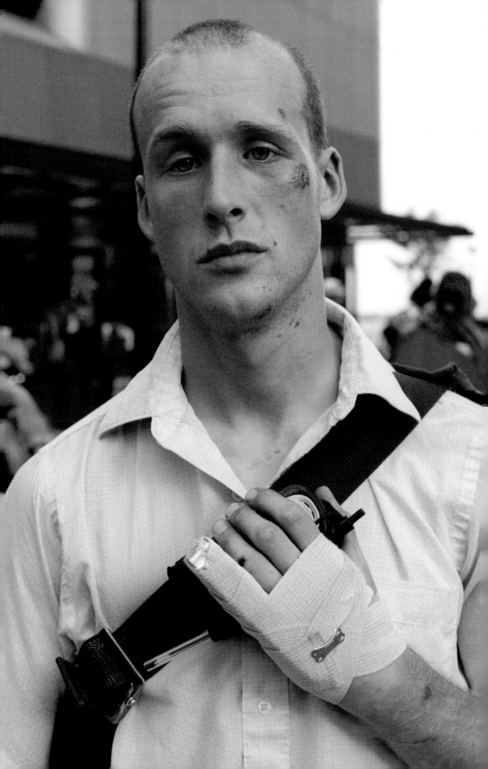

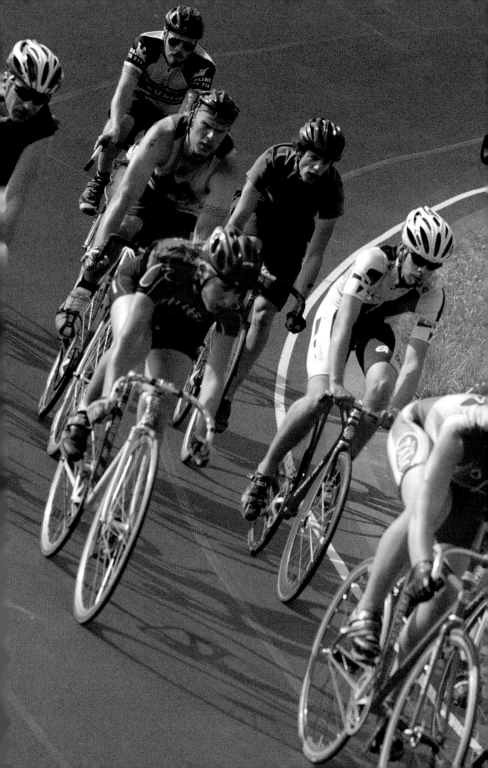

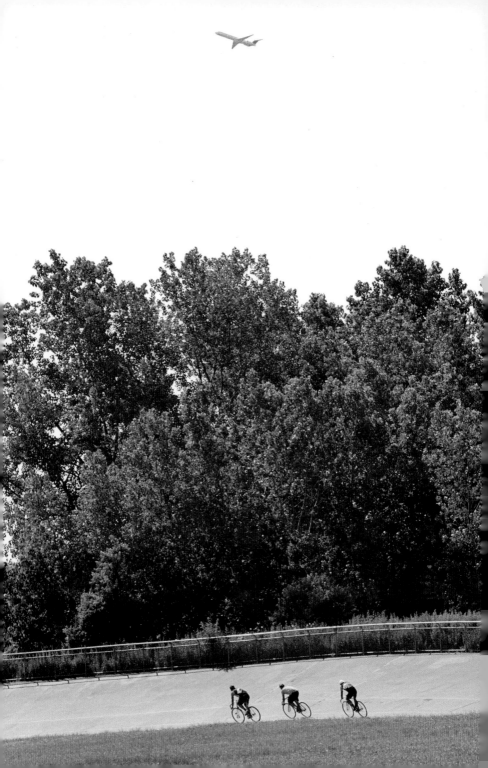

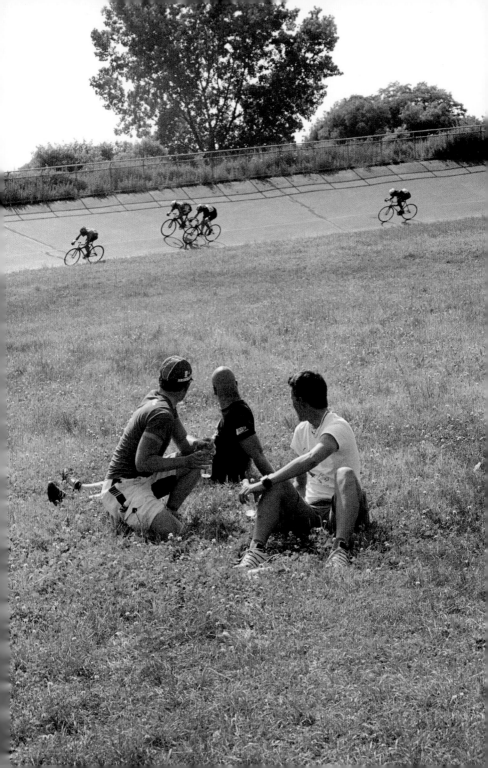

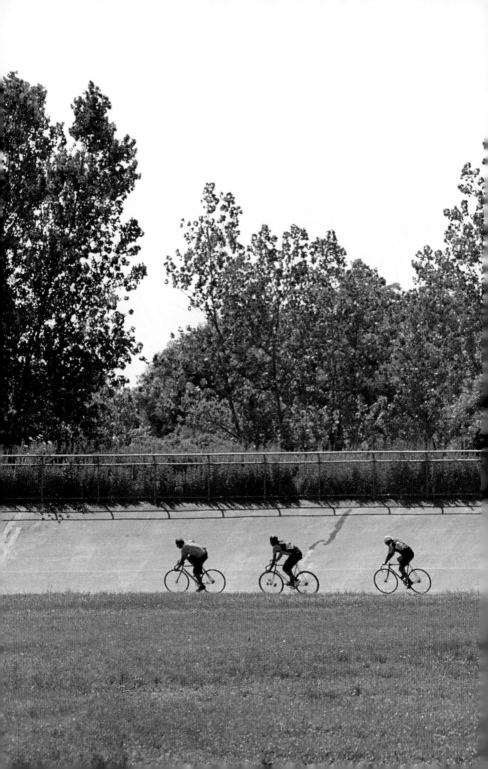

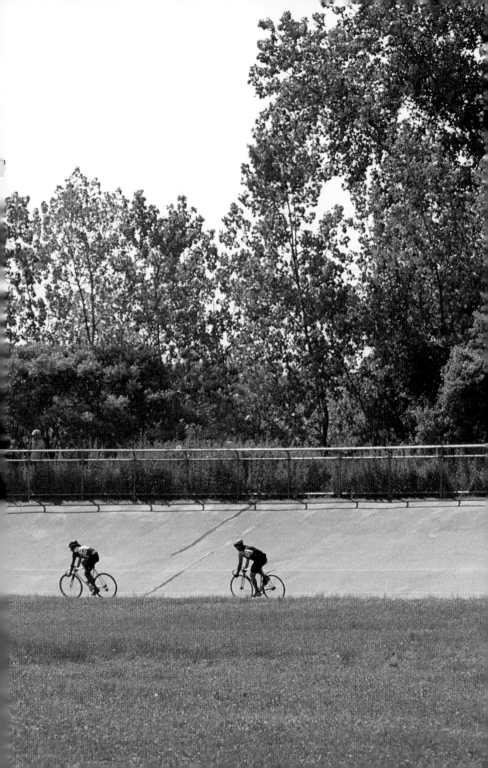

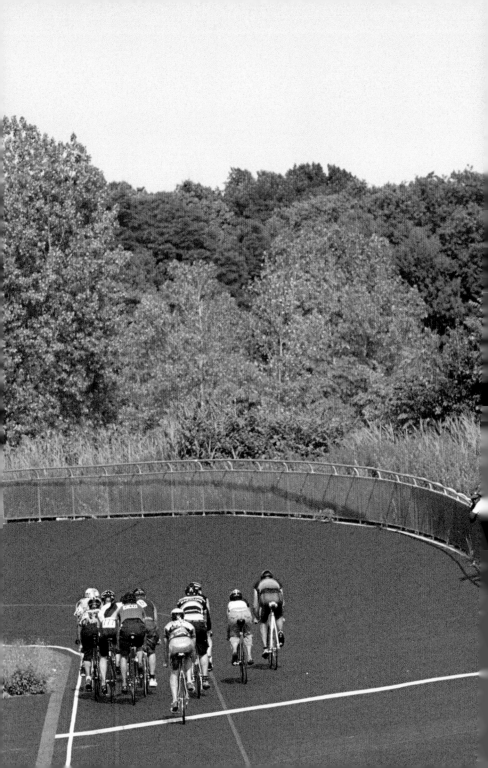

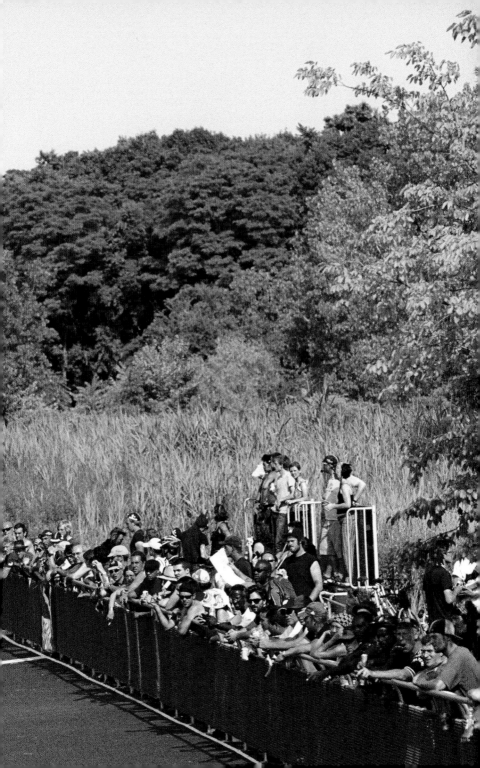

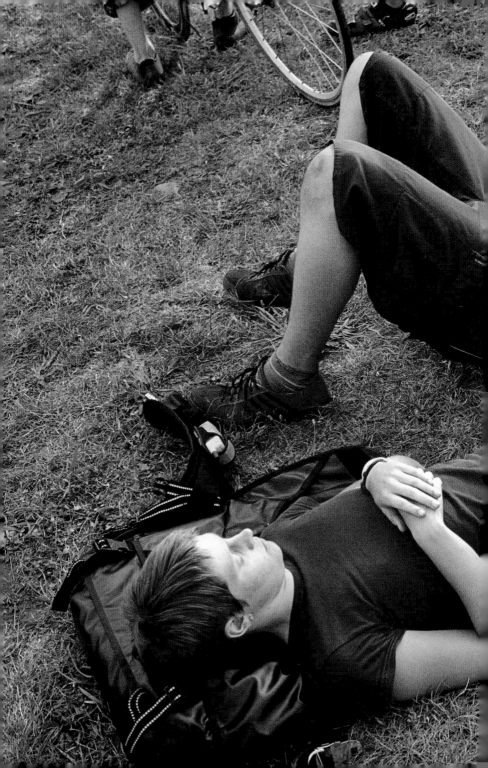

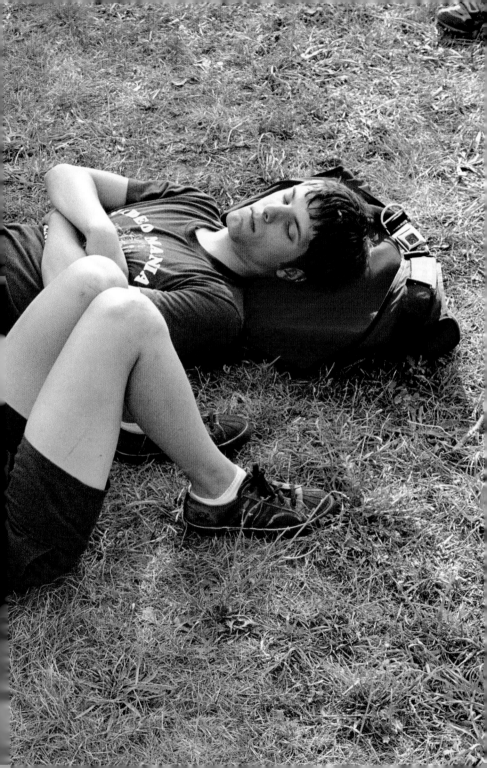

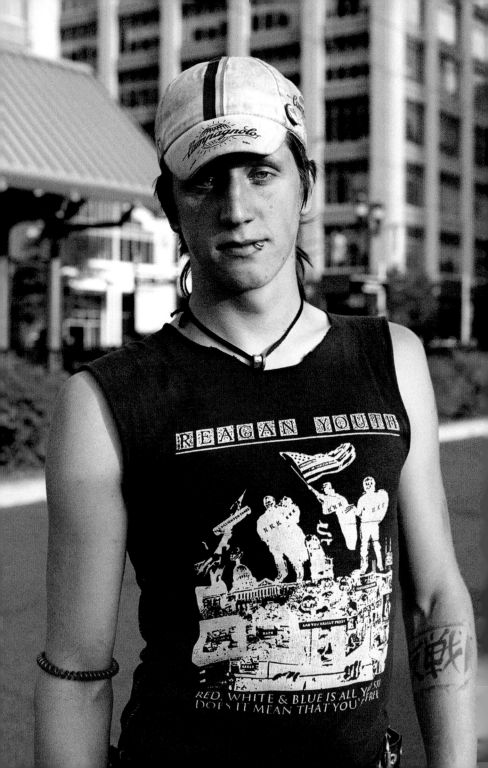

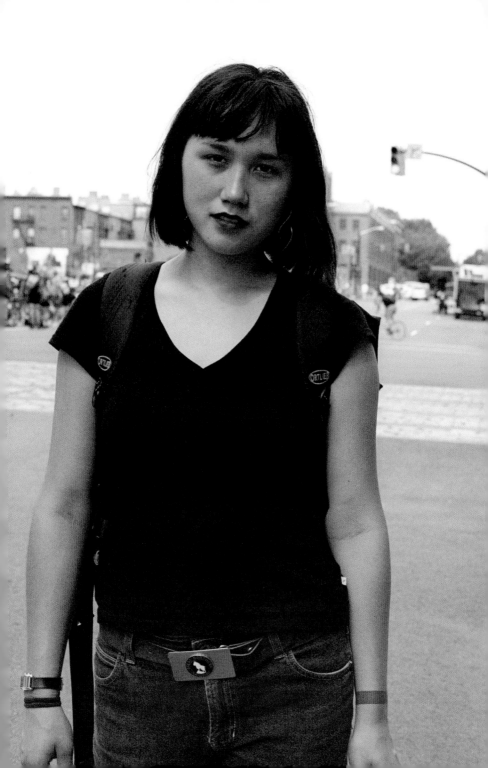

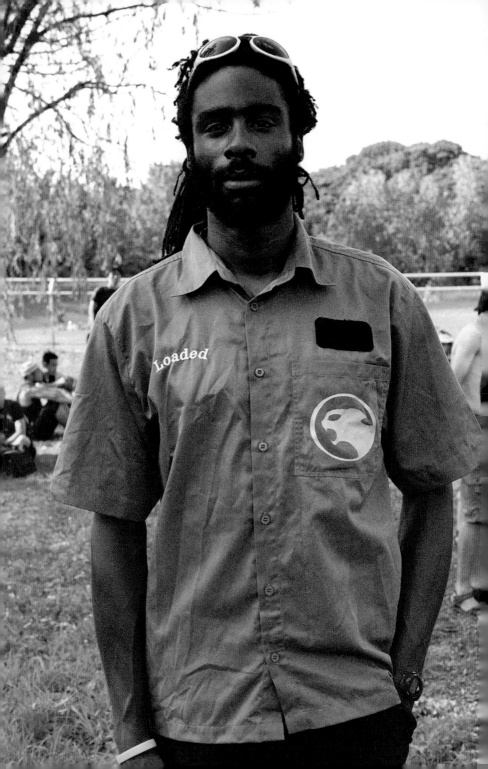

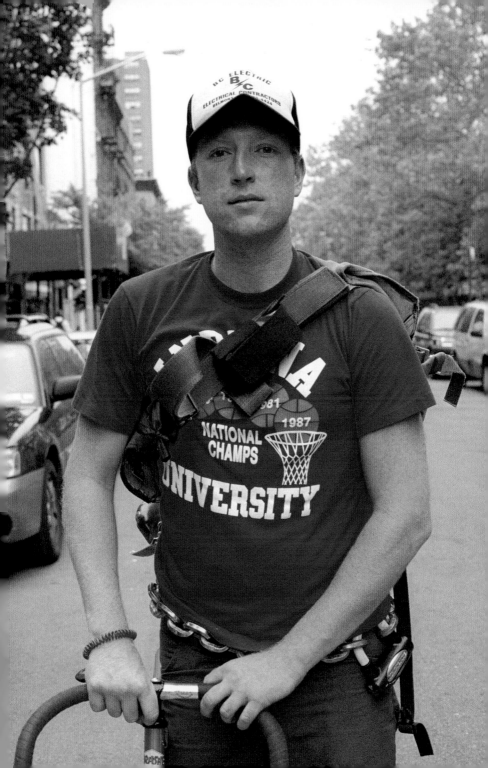

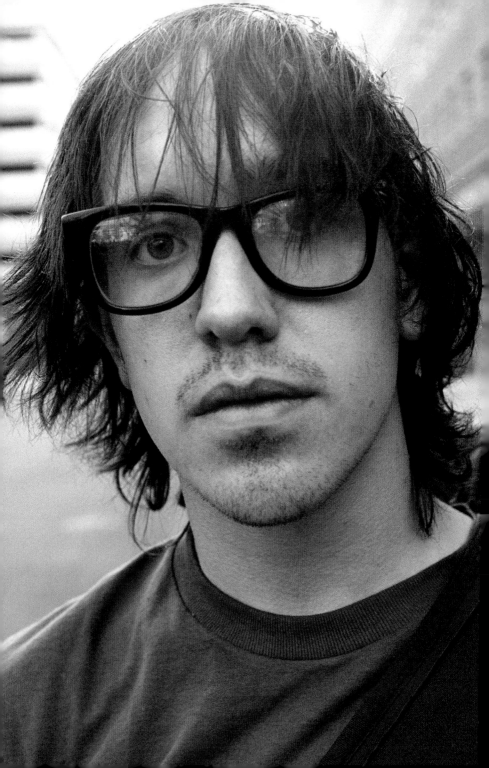

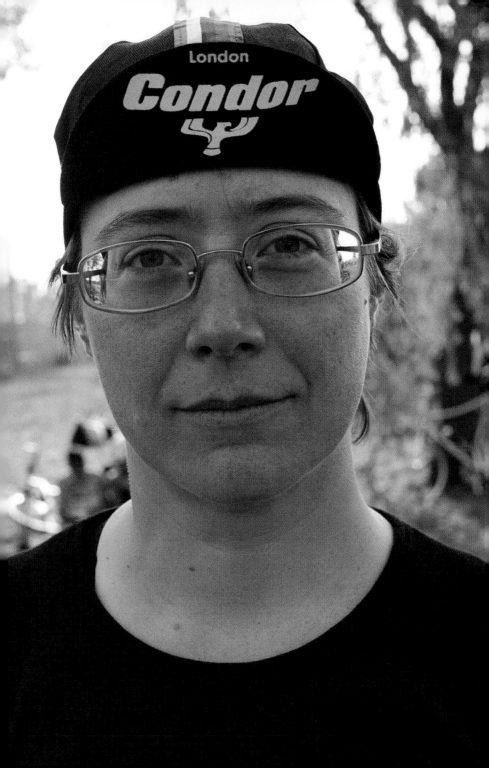

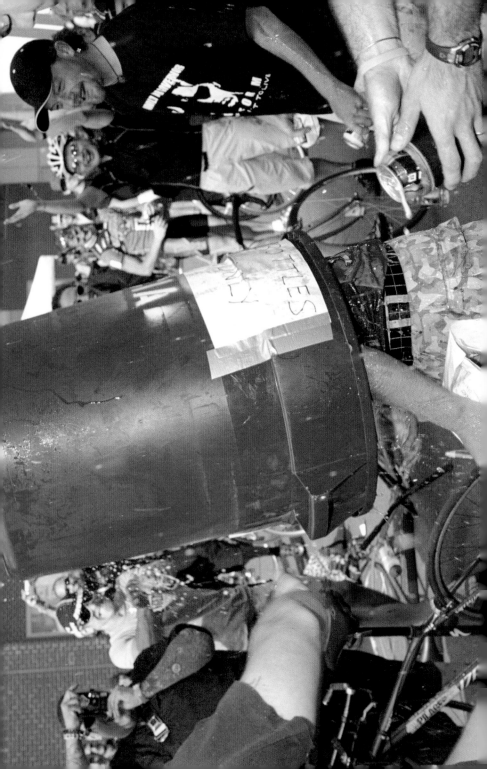

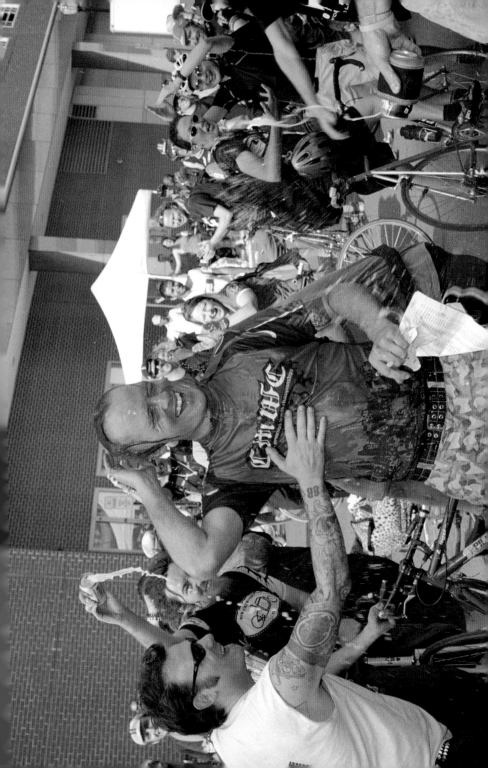

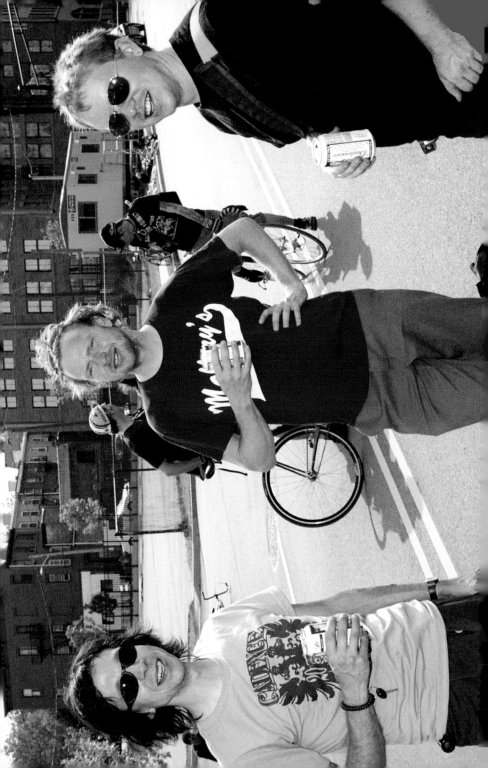

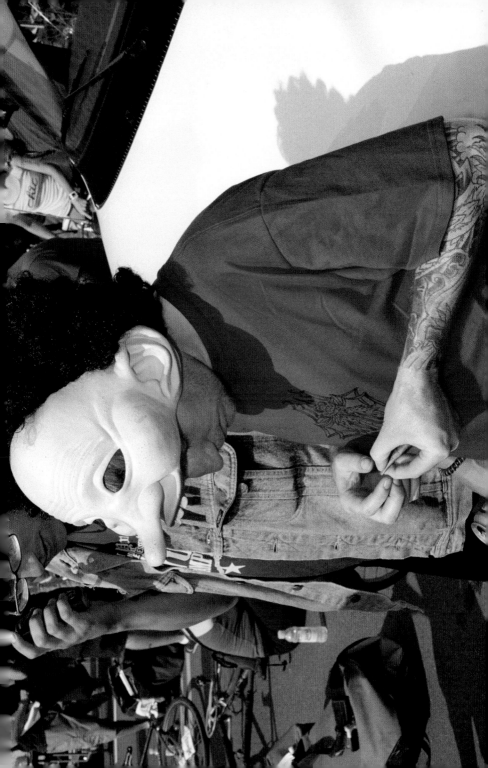

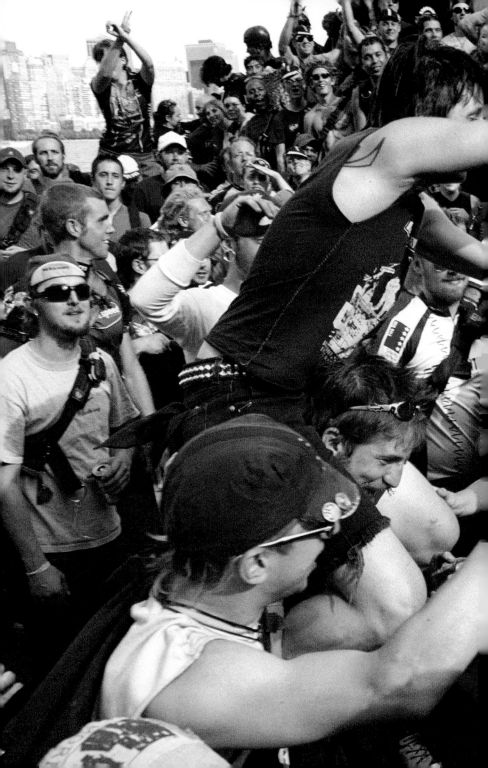

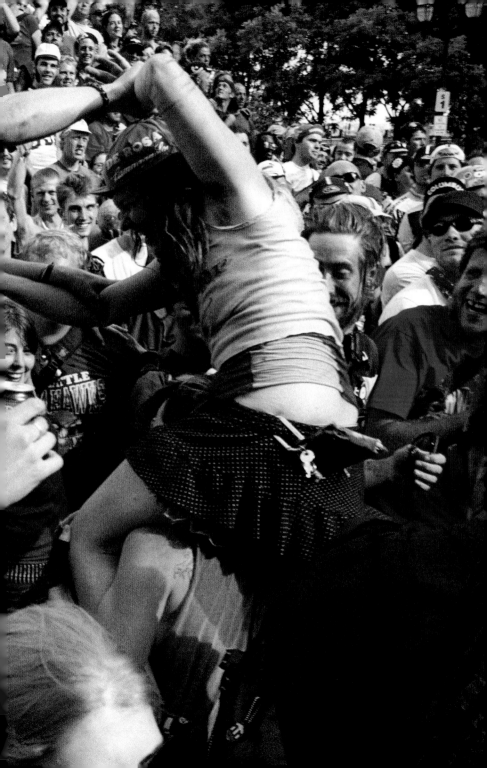

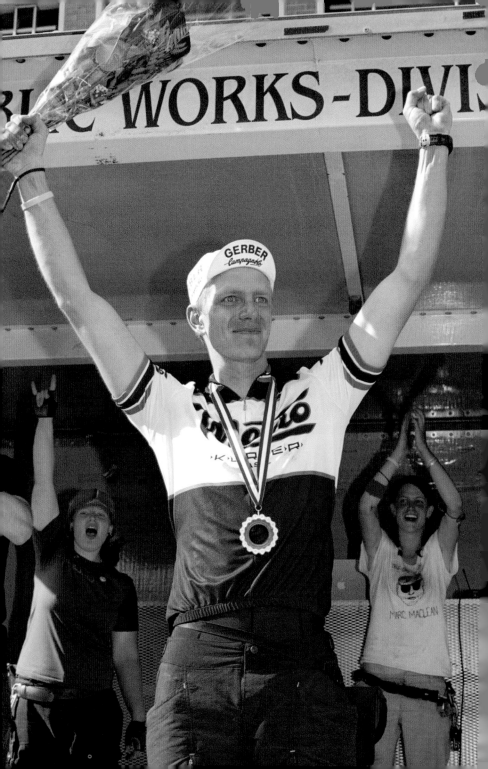

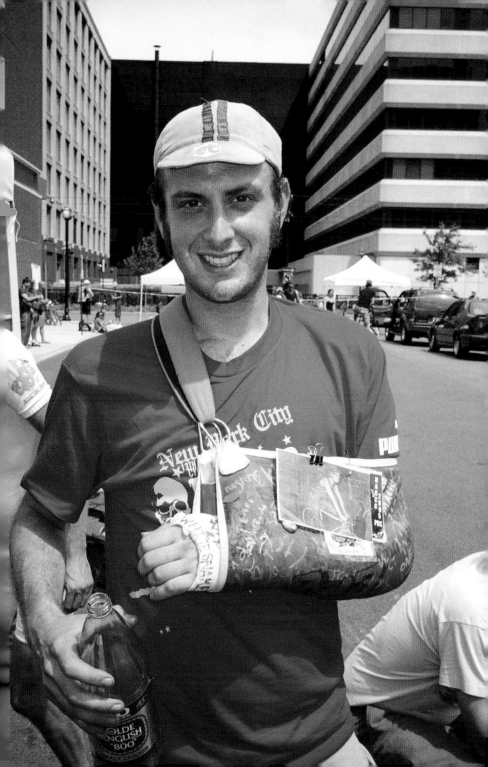

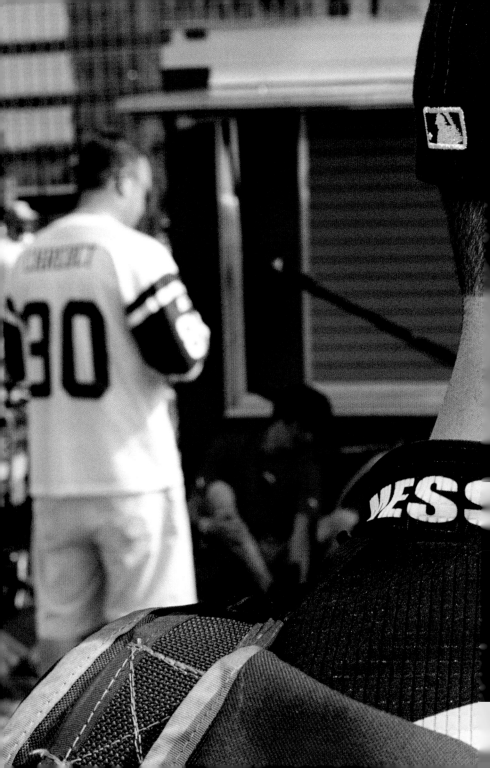

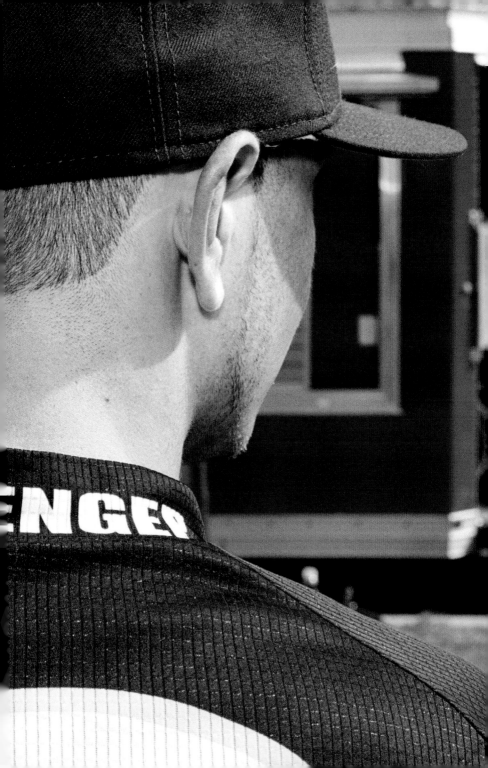

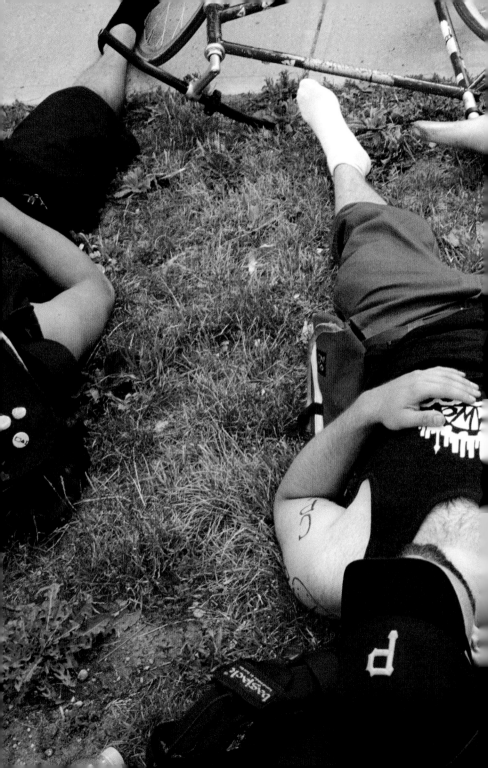

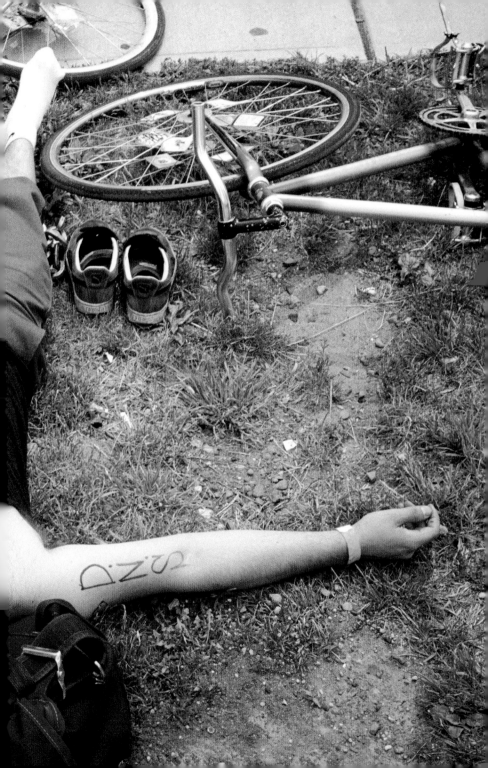

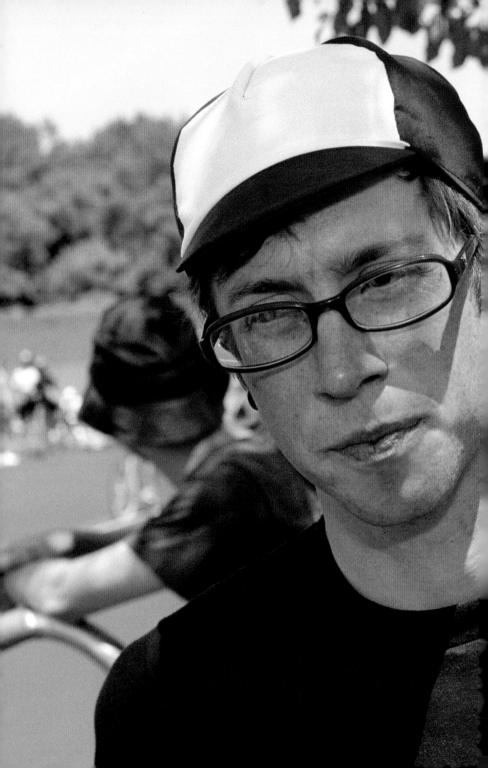

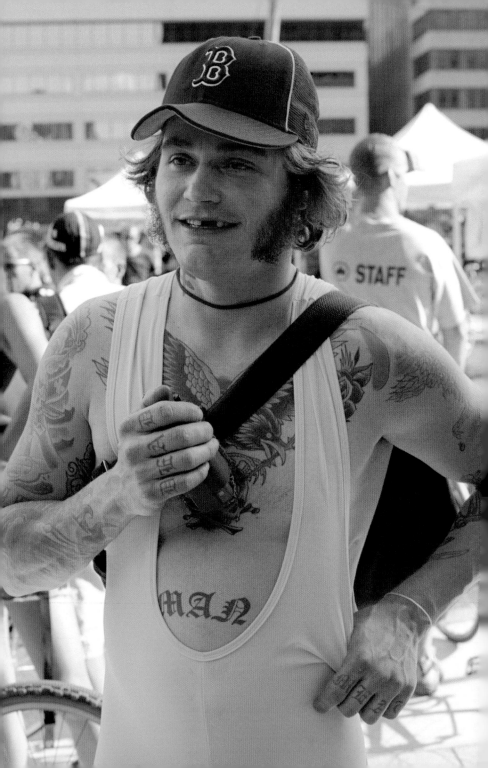

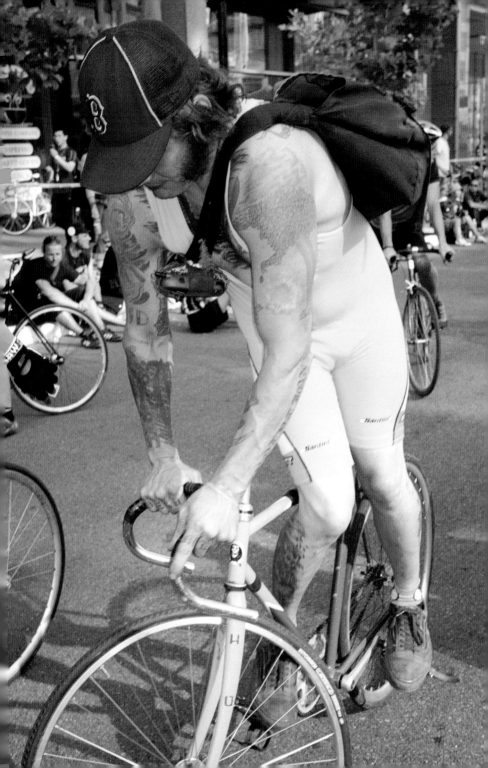

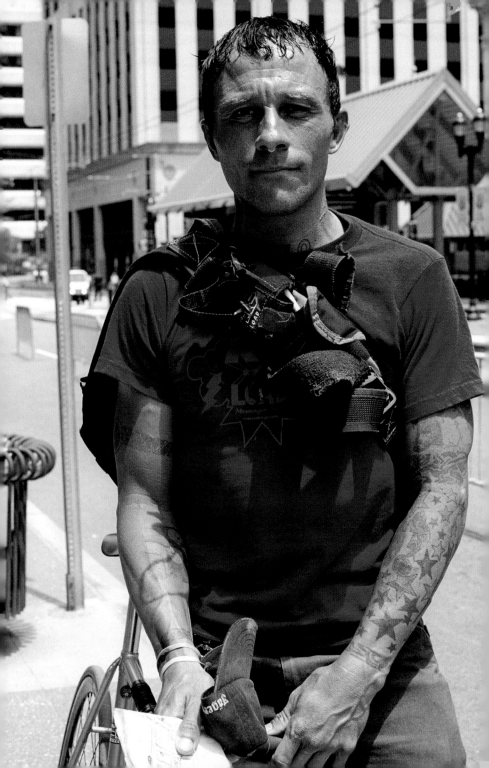

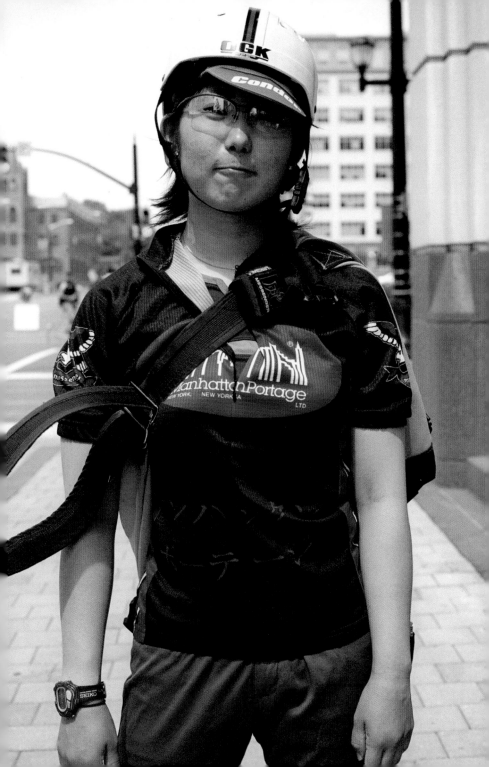

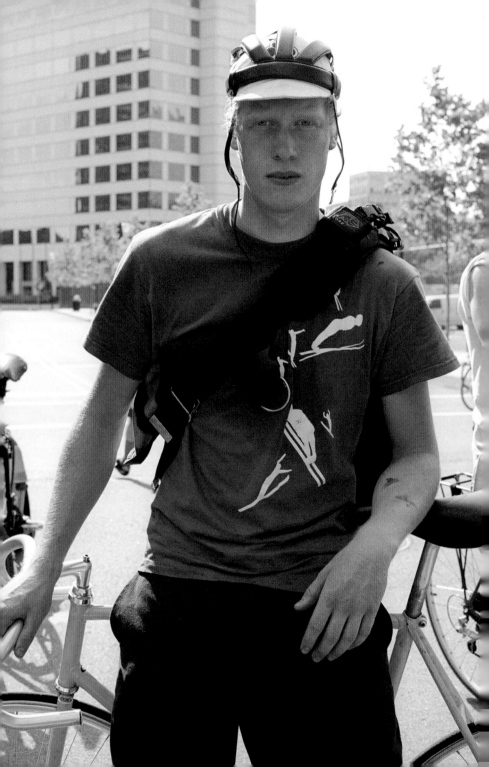

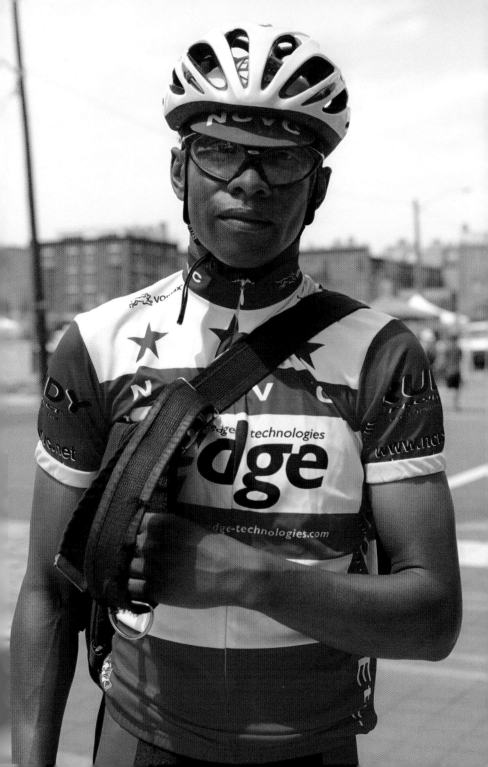

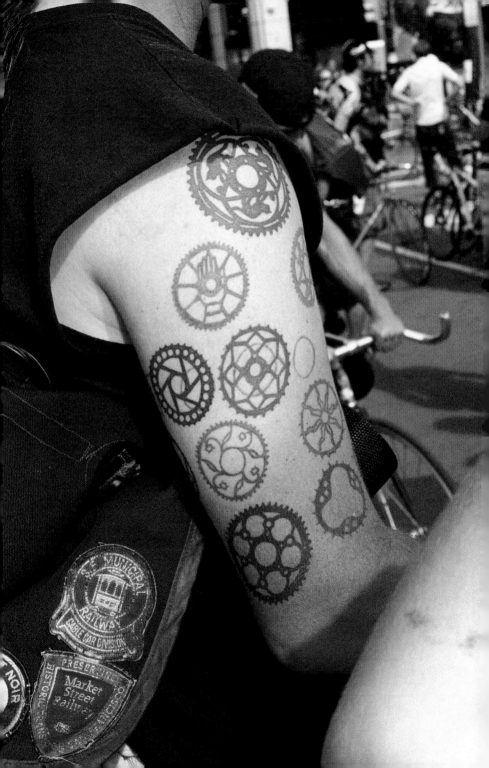

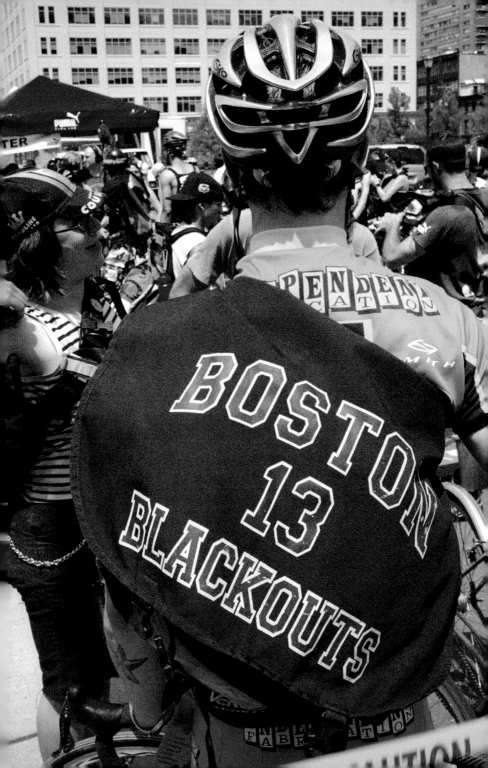

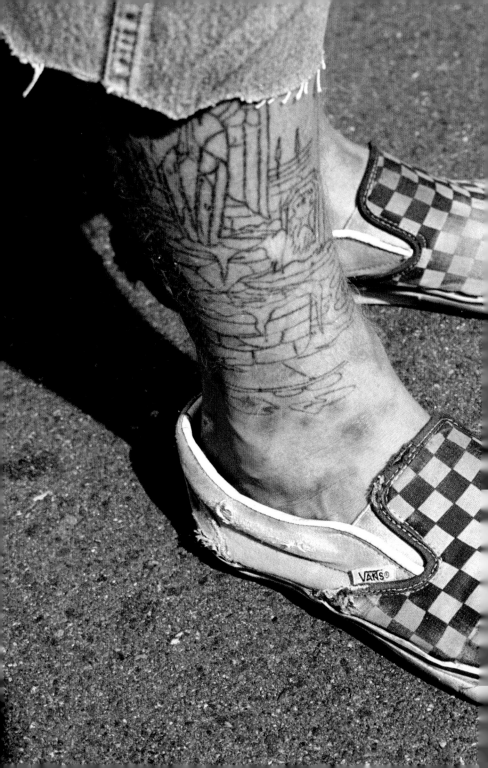

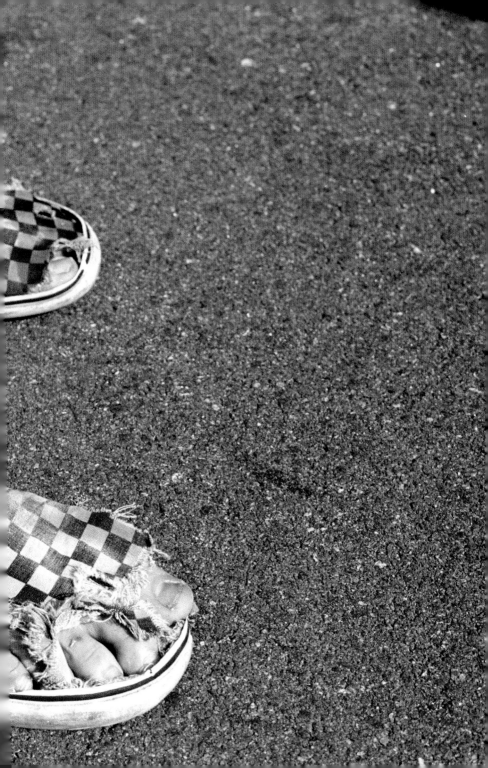

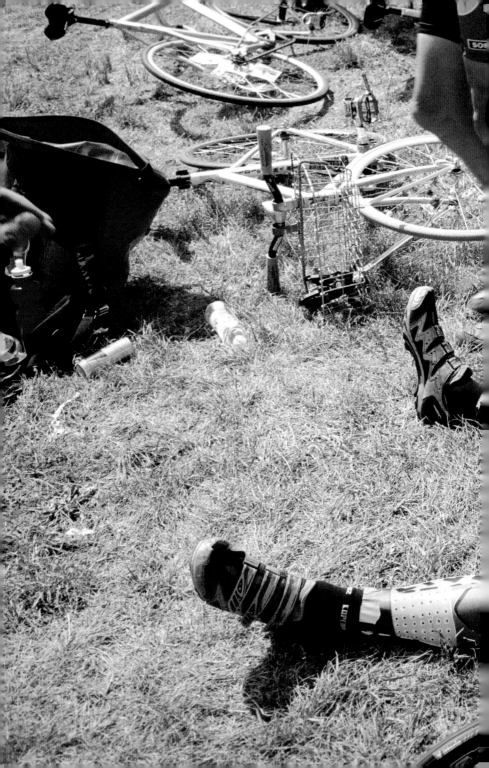

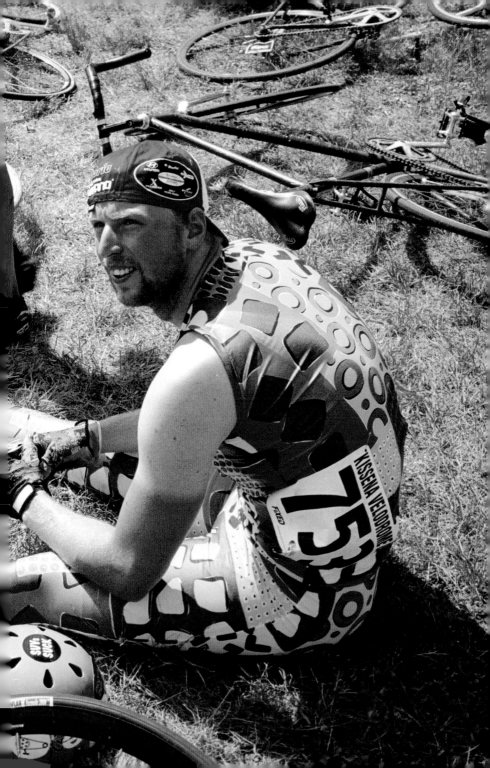

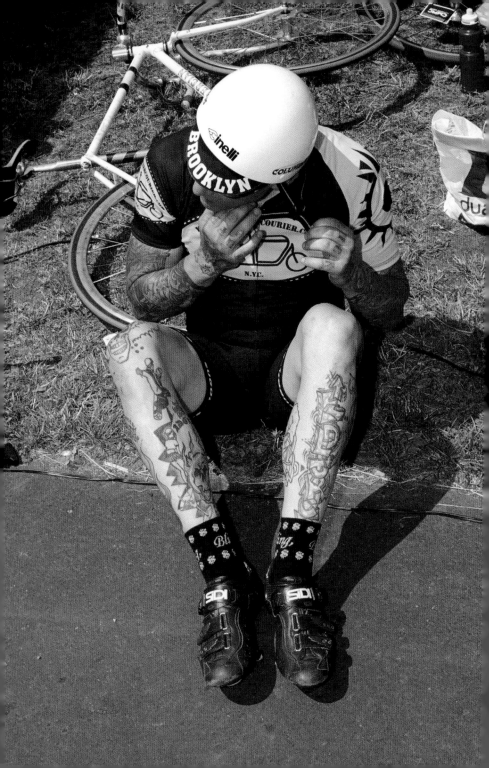

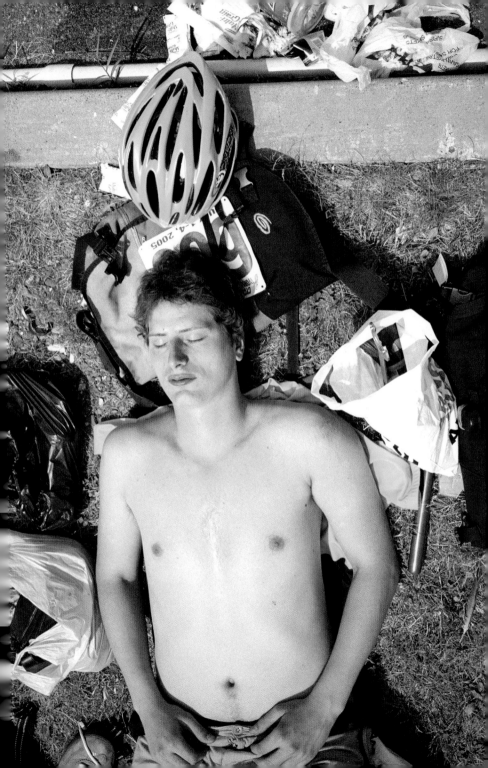

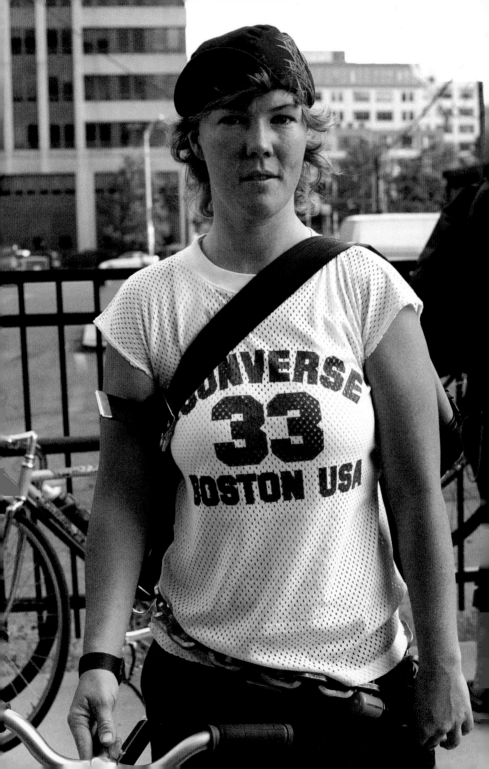

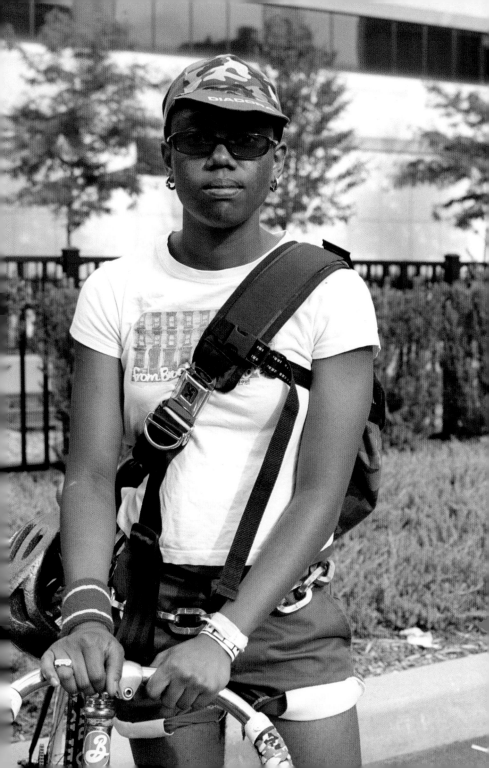

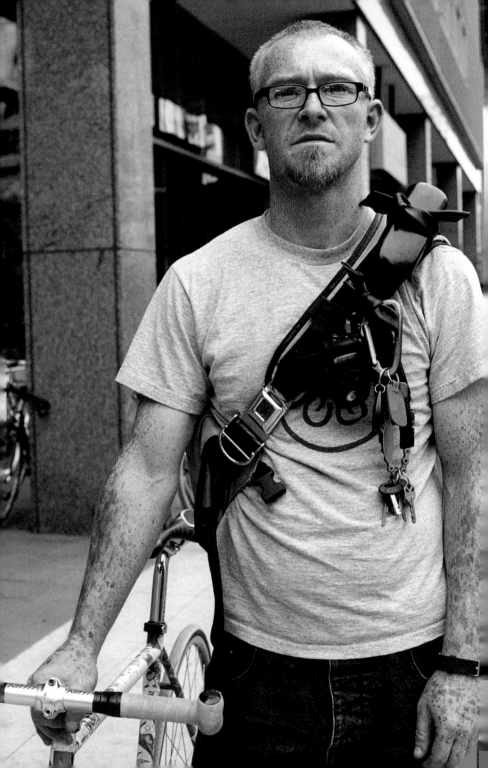

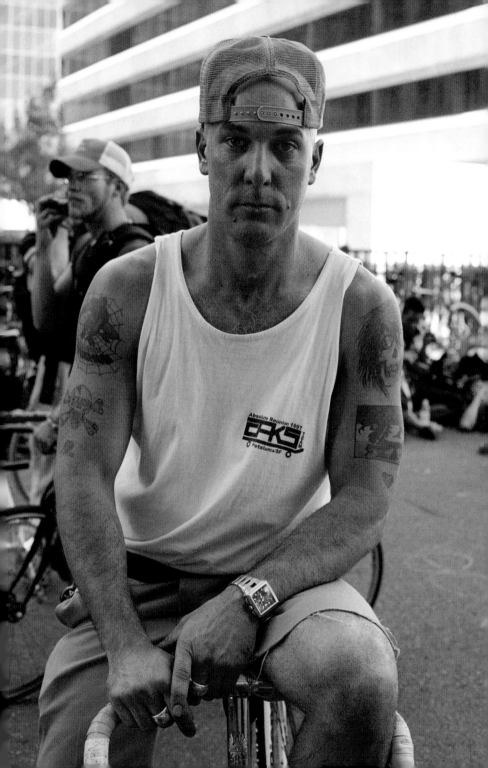

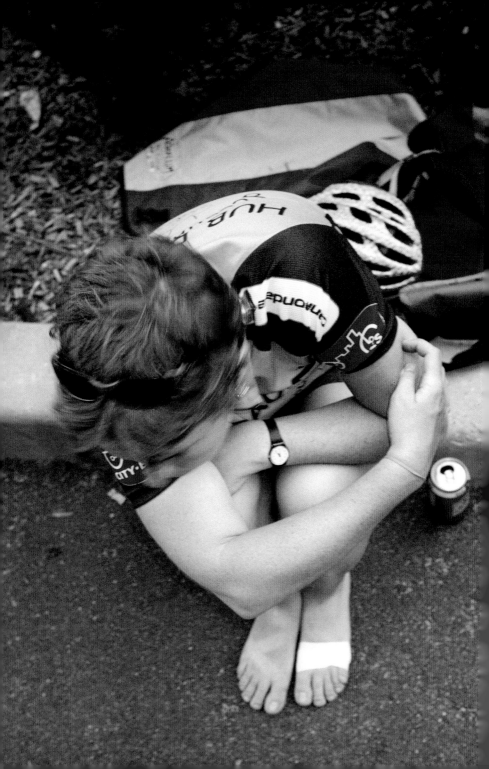

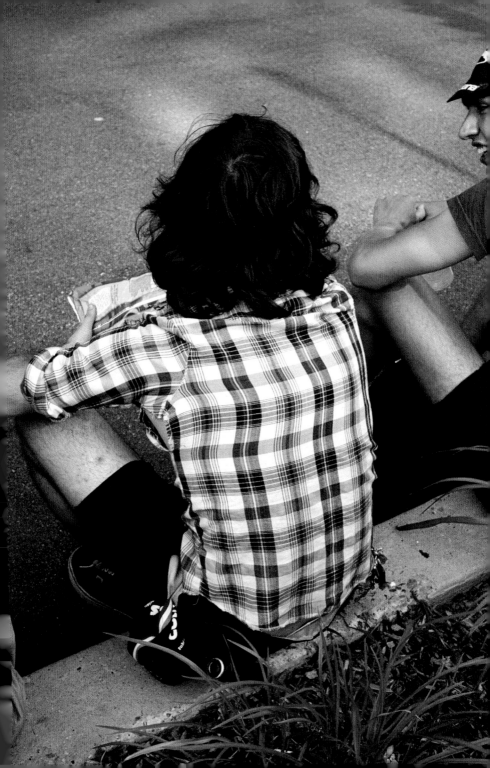

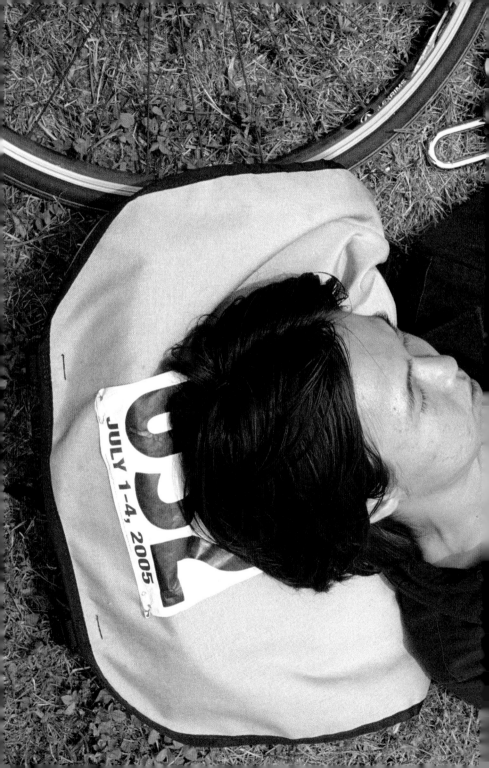

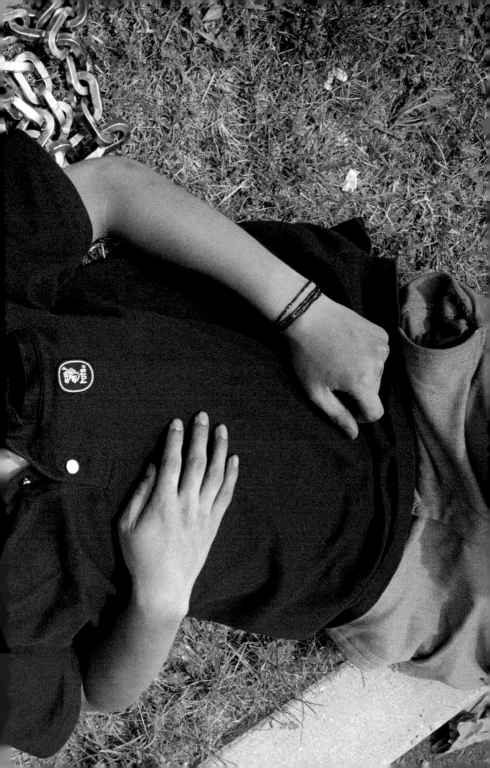

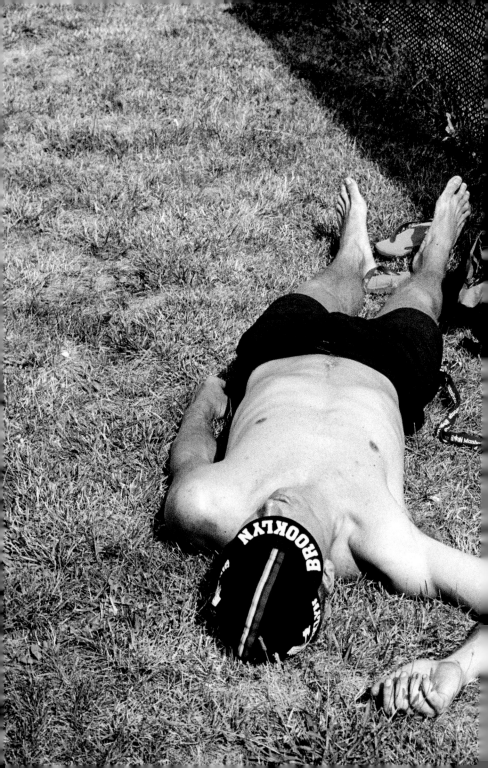

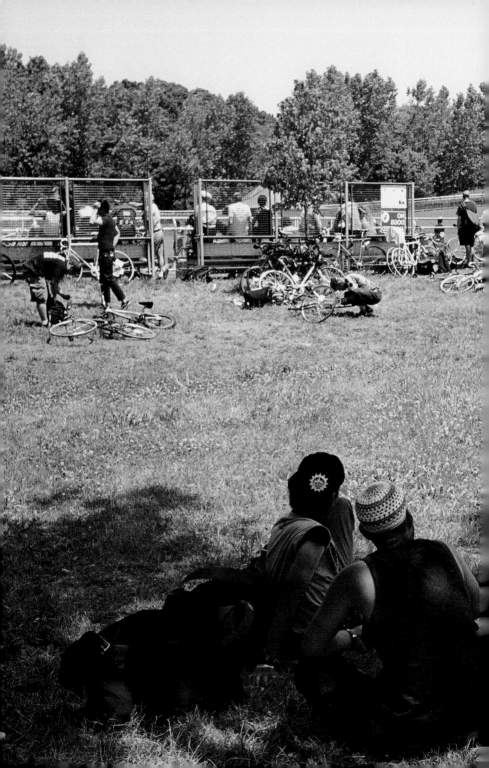

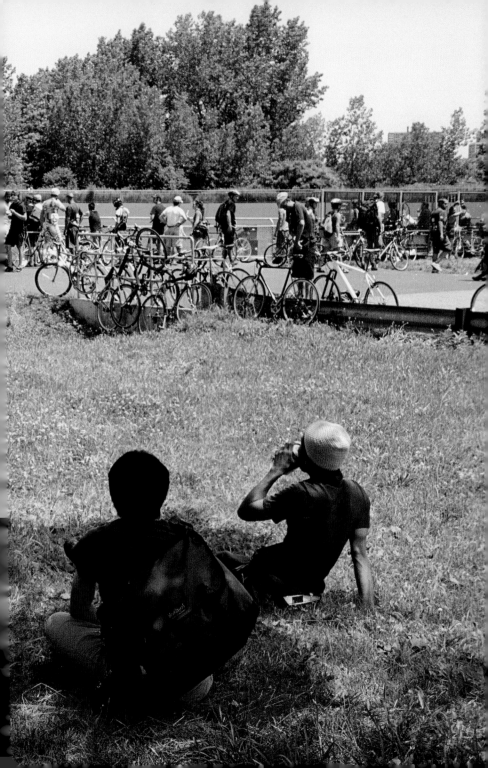

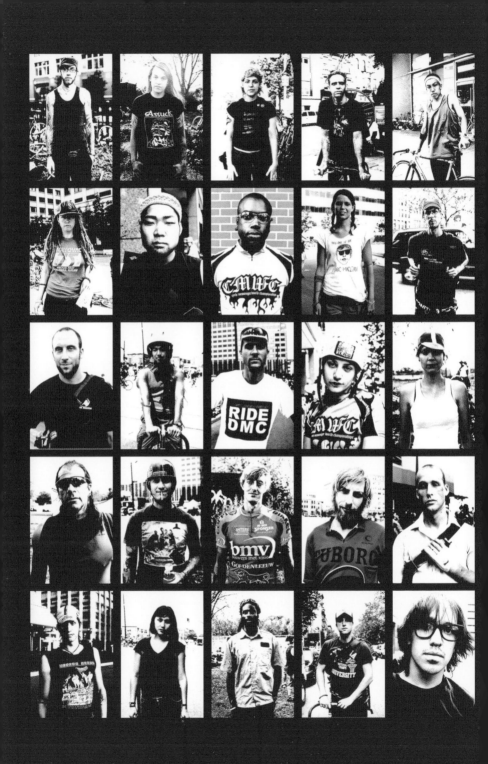

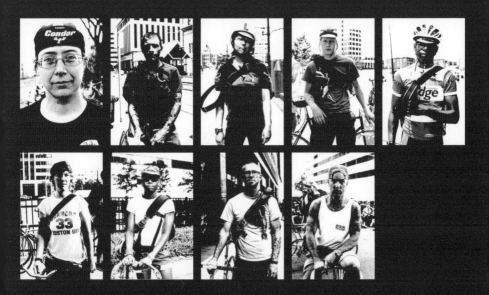

OPPOSITE PAGE: Eric, NYC; KT, NYC; Charlette, NYC; Jonny Pacific, Oakland; Jun, Tokyo; Sara, San Francisco; Yu, Tokyo; Prentiss, NYC; Stacy, NYC; Andy, NYC; Mo, Berlin; Tak, NYC; David, Copenhagen; Sara, Winnipeg; Emily, Richmond; Steve, NYC; Esher, Philadelphia; Morgan, NYC; Jonas, Copenhagen; Jim, San Fransisco; Unknown; Victoria, Seattle; Corey, Washington DC; Travis, San Fransisco; Josh, Austin.

THIS PAGE: Rivadene, London; Sharky, Philadelphia; Chie, Kyoto; Red, Copenhagen; Kevin, Washington DC; Suss, Copenhagen; Janine, NYC; James, Edinborough; Ted Shred, NYC.

At the age of 6, I thought there was nothing cooler than checkerboard "California Lite" pads on a BMX bike frame. I wanted a set but owned a Huffy, a bike I considered unworthy of such pads. Pads like that belonged on a Hutch or a Haro or something expensive. Now, years later, I have a worthy bike, don't need pads, and I've relocated to New York City. As a newcomer to the city in 1998, I bought a digital video camera and started filming skateboarding. I liked the aesthetic and feel of skateboard videos and decided that style of filmmaking would lend itself well to filming messengers while they were doing deliveries. I found messengers to be a hardworking, often intense people; most of them were excited about being filmed and welcomed the experience. I would skateboard around—usually in midtown—and shoot rolling interviews day after day, until I had 80 hours of footage! With the help of friends Ana Lombardo and Kevin Trageser I finished PEDAL in 2000, the film premiered at the 2001 South by South West Film Festival, and aired on the Sundance Channel for the following two years. My admiration for New York's fastest comes from my enthusiasm for cycling in general. There is a certain ethos that bikers share, and messengers just seem to be more aware of it than the rest of us. A friend told me he heard Skeletor let out a "hep hep" the other day on the street—I was psyched.

Messengers are a diverse group of people with different reasons for riding. Some rely on it as a job, others embrace it as a lifestyle, and some get into racing. The first Cycle Messenger Championships (as it was called at that time) was held in Berlin in 1993. It was created by Achim Beier, boss of Messenger Berlin, and his assistant Stefan Klessman. The two were inspired to start the Championships after several conversations with DC- and NYC-based messengers about organizing such a race. Since then the Cycle Messenger World Championships has grown and is held annually in major cities in Europe and North America. Check out http://www.messengers.org/ifbma/history.html for more on the history.

In 2005, New York City hosted the 13th CMWC over July 4th weekend. There were 711 racers, I photographed events in Jersey City and Queens. Being at the CMWCs sort of felt like being in a heavy metal show's parking lot combined with an Olympic time trial. It's a funny mix of cigarettes, alcohol, intense athleticism, and expertise. In the three days I spent taking these photos, I got heat stroke, or heat poisoning, or whatever the term is—that might be some indicator of what the weather was like for those competing in the races. As an outsider to the messenger community I relied on the trust and cooperation of everyone featured in the book and film. I'd like to thank everyone who made this project possible. I'd like to add a special thanks to Diana Hong for designing and laying out this project and for her love, support, and creative collaboration. Ride safe!

Peter Sutherland, January 2006, NYC

Peter Sutherland is a filmmaker and photographer. He worked as a director of photography on *Stoked*, a documentary film about famed skateboarder GATOR, directed by Helen Stickler. In May, 2004, he released his first book, *AUTOGRAF: New York City's Graffiti Writers* (powerhouse Books, 2004) to worldwide acclaim. He has shown his work at Bape, Tokyo; colette, Paris; International Center of Photography, New York; and CC room, Berlin; among others. Sutherland is a contribuiting photographer to magazines such as *Tokion*, *Anthem*, and *VICE*. He lives and works in New York City.

Ana Lombardo is a native New Yorker and prop person on major motion pictures, most recently for Paramount, Universal Studios, and HBO. During hiatuses, Lombardo bicycles and scuba and sky dives around the world, and continues her research on global subcultures. She currently lives in New York and works on the hit HBO TV series *The Sopranos*.

ZEPHYR is a graffiti writer and a former bike messenger. He is the author of *Style Master General* (Regan Books, 2001), the biography of Dondi White.

Ken Miller was born and still lives in Brooklyn, New York. Subsequent to his birth he went to college, traveled the world, made movies, wrote books and articles, went to lots of parties, and met cool and interesting people. For the past three years he has been the editor-in-chief of *Tokion* Magazine.

SWOON has made public art in New York for five years, and has undertaken projects ranging from billboard alterations to site-specific installations. She is the founder of Toyshop Collective, and has collaborated with collectives including Glowlab, Black Label, Change Agent, The Madagascar Institute, and the Barnstormers.

The New York Bike Messenger Foundation (501c3) was founded in 2004 by working messengers to aid our brothers and sisters who are injured on the job, and to assist the families of messengers who die while working. An overwhelming majority of Bicycle Messengers work with no coverage or benefits. Our goals include affordable health care and a centrally located office to promote workers rights and education. We are a nonprofit organization that raises money through community events and our online store, http://www.nybmf.org/. For more information, please visit our main site, http://www.nybma.com/.

THANK YOU:

The New York Bike Messenger Association, Diana Hong, Ken Miller, SWOON, ZEPHYR, Evangelis, Skeletor, Eric Baker, Marco & Marie, Daniel Piwowarczyk, David Mashburn, Ginny Hwang & Danny Hong at Ephelant, PERKS & MINI, Ben O'Connor, Kyoko Fukuda, Jason Evans, Ana Lombardo, Kevin Trageser, Andrew Sutherland, Angelo Fabara, Ben Dietz, Ben Stewart, Squid, Amy Bolger, Trackstar, PSYOP, Jack Youngelson, Uncle Don & Kim, The Outpost, Jan Sutherland, Jeff Saunders, Cinema Capital, Hosi Simon, Gerhard Stochl, Diapostive Lab, Helen Stickler, Steve the Greek, Tomoko Okamoto, The Bronx Monx, Jay & Dot, Marty, Brendt Barber, The Bicycle Film Festival, Chinatown Soccer Club, Ian Bricke, The Sundance Channel, Roger Gastman, Tim Barber, Gavin Thomas at NIKE, Bill McMullen, Lodown, VICE, Gramma & Pa, ARKITIP, Khairi Mdnor, Matthew Newton, Wendy Dembo, Jeff Staple, Chris Noble, Woo Cho, Trudy Chan, colette, Bape, Circle Culture Berlin, Dar Meshi, Beinghunted.com, Mass Appeal, Bagel Zone, Ana Pena, Silver Warner, Red Tops, Michael Martin, Jason Goodman, Saidah Blount, Nicholas Weist, Kiki Bauer, Sara Rosen, Craig Cohen, Daniel Power, Susanne König, Mine Suda, Isabel Babcock, Wes Del Val, Emily Power, Jane Catucci, Vittoria Lui-Madonia, Michael Fossenkemper at Turtle Tone Studio, Dexter Benjamin, Yuka Iwakoshi, Daisuke Nishimura, Hidetaka Furuya, Canon USA, Devin Bennett, Steve R. & Nards at 5 Boro Skateboards, Matt Newton, Nick Haggard, Hodari, Kazumi Asamura, Ryan Fenson-Hood, Matt Clark, JK5, Jim Mangan, Greg Thurik, Kid, Raina Kumra, Duncan Hamilton, Tokion, Trudy Chan.

SPECIAL THANKS:

NYC-based PSYOP is an inspiring culmination of creativity, collaboration, and production focused on providing visual solutions in motion for the advertising & marketing, video gaming, broadcast, and music video industries. Founded in 2000 by five creative partners, the company continues its insurgence into these industries with its distinct conceptual approach, collaborative nature, and dynamically fresh aesthetics. Seamlessly blending the disciplines of design, animation, and live-action directing, PSYOP approaches elaborate challenges with extraordinary creative and technical flexibility, providing unique solutions and design with meaning. PSYOP's appropriation of the identity of the United States government's division of psychological operations represents a critical awareness of the power that advertising has and the importance of accurate and targeted communications. Their motto is "Persuade, Change & Influence." www.psyop.tv

Trackstar★

Trackstar is special. Trackstar is one of a kind. Trackstar stands out. Trackstar is a prince among men. Trackstar, ride to live, live to ride. Trackstar knows track bikes and drunken shenanigans. Trackstar knows two things, causing trouble and riding bikes. Trackstar knows a thing or two about track bikes. Trackstar is the best of the best, the cream of the crop. When it comes to track racing and drinking beer, Trackstar knows best. Trackstar, not just a bike shop. Trackstar, actual messengers, not just a bunch of trackstars.
www.trackstarnyc.com

PEDAL

Published in the United States by powerHouse Books,
a division of powerHouse Cultural Entertainment, Inc.
37 Main Street, Brooklyn, NY 11201-1021
telephone 212 604 9074, fax 212 366 5247
e-mail: pedal@powerHouseBooks.com
website: www.powerHouseBooks.com

Library of Congress Cataloging-in-Publication Data:

Sutherland, Peter, 1976-
 Pedal / photographs by Peter Sutherland.
 p. cm.
 Includes documentary DVD which premiered in 2001 at the SXSW film
festival.
 ISBN 1-57687-314-5 (slipcased paperback)
 1. Bicycle messengers--New York (State)--New York--Pictorial works. 2.
Bicycles--New York (State)--New York--Pictorial works. 3. Cycle Messenger
World Championships (2005 : New York, N.Y.)--Pictorial works. I. Title.
 HE9755.N7S88 2005
 388.4'132--dc22

 2005056524

Paperback with DVD ISBN 1-57687-314-5

Printing and binding by Pimlico Book International, Hong Kong

Book design by Diana Hong, www.esquila.com

A complete catalog of powerHouse Books and
Limited Editions is available upon request;
please call, write, or ride to our website.

10 9 8 7 6 5 4 3

Printed and bound in China